IMAGES
of America

LOST VILLAGES OF
FLAGSTAFF LAKE

Alan L. Burnell and Kenny R. Wing

ARCADIA
PUBLISHING

Published by Arcadia Publishing
Charleston SC, Chicago IL, Portsmouth NH, San Francisco CA

Printed in the United States of America

Library of Congress Control Number: 2009943404

For all general information contact Arcadia Publishing at:
Telephone 843-853-2070
Fax 843-853-0044
E-mail sales@arcadiapublishing.com
For customer service and orders:
Toll-Free 1-888-313-2665

Visit us on the Internet at www.arcadiapublishing.com

*This book is dedicated to all the residents of the Dead River
Valley, both living and deceased, who sacrificed their homes
and much of their heritage for the creation of Flagstaff Lake.
The reluctant surrender of the land they so deeply cherished
for the perceived "greater good" of the entire state
is an unimaginable act of heroism.
We salute each and every one and sincerely hope
that this book does justice to that unselfish act.*

IMAGES
of America

LOST VILLAGES OF
FLAGSTAFF LAKE

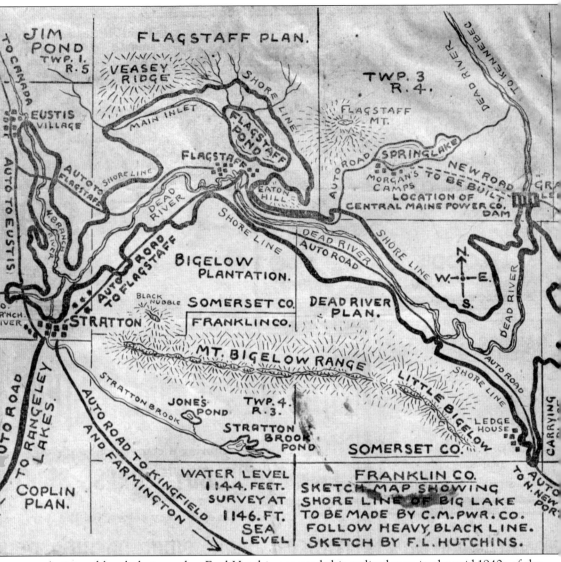

Artist and local photographer Fred Hutchins created this stylized map in the mid-1940s of the proposed new Flagstaff Lake. (Courtesy of Dead River Area Historical Society [DRAHS].)

CONTENTS

ACKNOWLEDGMENTS

The authors would like to acknowledge with appreciation the assistance of the following people and organizations who not only allowed us to utilize their photographic material, but also gave us great insight into the lives of people in the Upper Dead River Valley prior to it being inundated beneath the waters of Flagstaff Lake: Duluth and Betty Wing (DEW), Forrest and June Leavitt Parsons, Kenny R. Wing (KRW), Dead River Historical Society (DRAHS), Thomas and Marie-Luise MacDonald, Maine Public Broadcasting for use of parts of the video entitled *Power Lines*, Fred Hutchins, Arthur E. Wright, Lydia Bryant, Ruey W. Stevens Baldwin, Frances Savage Taylor, Central Maine Power Company (CMP), Bill Hansen, Caleb Stevens (of CA), Anna and Bill Smart, Earl Jr. and Wendy Wyman, Brad Crafts, Maine State Archives, Vernon Bean, Franklin Sargent, Wendell Wing, and Mitchell Quint.

We would like to encourage readers who would like additional information about everyday life in the Dead River Valley to read *There Was a Land: 1845–1949*, a compilation of short stories written by individuals who were born and who lived where Flagstaff Lake stands today. This book was compiled by the Flagstaff Memorial Chapel Association, and the proceeds from its sales support that association.

As with any journey into history, there inevitably comes a time when someone comes forward with new information, material, and photographs that were not available to the authors when this book was written. If anyone has additional information and/or photographs that you would like to share with the authors, please feel free to contact us, and we will do our best to include them in the proper archives.

INTRODUCTION

The western mountains of Maine have for millions of years been at a crossroads both on a geological time line as well as a historical time line. Housing some of the oldest bedrock in the state, it is where the current landmass of Maine, created far out in an ancient ocean, was pushed onto the original Laurentide Shield landmass, a crossroads between old and new landmasses.

The main landmass of Maine was created hundreds of miles off shore in an ancient ocean, the results of disintegration of an island. Over millions of years it migrated to the west as the ancient ocean closed and eventually ended up being pushed up onto the existing North American continent and Laurentide Shield landmass. The remnants of this ancient landmass can still be observed in the western mountains at Chain of Ponds.

The overlying landscape has been changed several times by glaciers, the most recent one exiting the area around 12,000 years ago. It left behind today's landscape, modified by ice and continuous erosion, which has sculpted out the valleys and lake basins and rounded over the hills and mountains. The melting glaciers further manipulated the landscape through erosion and deposition of transported material to create its present appearance. The Dead River was created during this melt period as glacial Lake Bigelow, which was created by an ice dam at Long Falls as it disgorged its water into the Kennebec River. Glacial Lake Bigelow, though larger, encompassed roughly the same area as the present-day man-made Flagstaff Lake.

Glacially sculpted, its surface land area is spectacular, with lake-dotted mountain terrain and rugged wilderness. It remains sparsely populated, attracting self-reliant, independent, and extremely hardy individuals.

The peopling of the area commenced with the recession of the glaciers as the area warmed and invasive vegetation began to spread. Paleo-Indian sites dating back 10,000 to 11,000 years have been discovered in this western mountain region. These sites were undoubtedly seasonal encampments for the nomadic hunter-gatherers as they moved between the mountains and the coast. Other more recent pre-contact period Native American sites are also quite numerous and scattered throughout the Dead River Valley.

The first recorded visit by a non–Native American was in 1761 by John Montresor, an English engineer. He traversed and mapped the area with Native American guides in order to determine if an attack on Quebec City from the south was feasible. He began his trek in Quebec City, then a part of the English empire, and traveled by canoe down the Dead River and Kennebec River to Fort Western (present-day Augusta). He created a map of much of the region between the Rangeley Lakes area and Moosehead Lake. Benedict Arnold would rely heavily on a version of this map during his march to Quebec City in 1775.

Benedict Arnold's expedition began in September 1775 in Cambridge, Massachusetts. The newly formed government of the United States believed that Canada was weakly defended by the British and wanted an easy victory that might lead to a quick ending to the war. Col. Benedict Arnold and 1,100 men were dispatched to attack Quebec City, the capital city of Canada. According

to plans, this was to be a quick strike delivered by an army that was to march up the Kennebec River and Dead River, through the wilderness of Maine, to the height of land on the Canadian border. From there they would journey down along the Chaudière River and on to Quebec City to launch their attack. This idea was precipitated partially because of the map and report by John Montresor. The unforeseen hardships encountered by Arnold and his men are well documented. Arnold soon realized that transporting 1,100 men and tons of supplies upriver at the onset of a Maine winter was vastly different than John Montresor traveling with 12 Native Americans by canoe. Additionally, although the map produced by Montresor contained the basic landforms, it lacked the detail necessary to properly conduct such an undertaking.

During his march to Quebec City, Benedict Arnold established an outpost on a grassy plot of land along the Dead River after the arduous portage over land from the Kennebec River. He established a camp to rest his weary and ill troops and to organize his supplies for the remainder of his journey. Allegedly his men cut a tree and squared it into a flagstaff. The staff was erected, and according to some accounts, Arnold himself climbed the staff and attached the flag of the newly formed United States, the first opportunity to do so since leaving Fort Western. Legend has it that some years later, a trapper in the region happened upon the rotted staff and erected another in its place so the spot would not be lost to history. It is from this flag-raising event that the village of Flagstaff received its name. Today a tablet commemorating this event is located in front of the relocated Flagstaff Memorial Chapel in Eustis. This tablet was on the village green in Flagstaff until the area was flooded by the current Flagstaff Lake.

The first settlers of the village of Flagstaff came in the early 18th century seeking timber to harvest. Thomas Lang and Ira Crooker made a trip to investigate the suitability of the area for a timber-harvesting operation around 1835. They soon realized that there were adequate timber resources in the area for a profitable investment, and the outlet to Flagstaff Pond would be suitable to supply the necessary waterpower. Around 1840, they dispatched their agent, Myles Standish (a direct descendent of the Massachusetts pilgrim) to the area. He built a sawmill and gristmill, along with a store, a hotel, and several residences. The village of Flagstaff was born, although at that time it was called Flagstaff Mills.

Concurrently with the settlement of Flagstaff, farmers and lumbermen were moving into the surrounding areas of Bigelow and Dead River. The abundant timber resources in these areas, along with good soil for farming the floodplain of the Dead River, encouraged early settlers. This would eventually give rise to the village of Bigelow on the south side of the river, adjacent to Flagstaff and the village of Dead River farther down river.

Early life in the area was difficult. The area was remote with few amenities. Travel was difficult, with narrow, unimproved dirt tracks and few places to cross over the Dead River. Snow was deep during the winter months, and disease often decimated entire families. Over time, Flagstaff village expanded with a tavern, an additional store, blacksmith facilities, and finally a covered bridge to cross the river. A church and schoolhouse were constructed by local residents, and later a Masonic lodge was chartered. Land was cleared for farming, and although the village never became large, life was near idyllic for its residents.

The villages continued to slowly expand and were granted plantation status (a form of local government midway between unorganized township and incorporated town, commonly used for sparsely populated areas and unique to Maine) by the Maine Legislature. The village of Bigelow languished and relinquished its plantation status in 1920, but Flagstaff and Dead River thrived until 1923, when the Maine Legislature authorized the construction of a dam downstream at Long Falls on the Dead River. In 1927, after long years of party bickering and legislative wrangling, a finalized bill was enacted that allowed the Kennebec Reservoir Company to construct the dam. It would be built on state land subject to a long-term lease agreement, and the company was authorized to obtain the necessary private land through the right of eminent domain.

The story of the Dead River Valley and the flooding of villages along the river is rooted in the story of the development of electrical power, the "electrification" of rural Maine, and, more specifically, the creation of Central Maine Power Company (CMP). In the late 19th century, electric

power in rural Maine was supplied by small, locally owned generating facilities that produced a very low volume of electricity. Most of these facilities, similar to the one in Flagstaff at the time, were run by waterpower and supplied electricity to a manufacturing plant of some kind and to local residents in off-peak hours. In Flagstaff village, the water-powered generator was located at Harry Bryant's mill. By 1900, Maine had a proliferation of these generation facilities, perhaps greater than any other state in the country.

Walter S. Wyman and his partner, Harvey D. Eaton, began purchasing many of these small individual generating facilities. Wyman's dream was an interconnected electrical system to service Maine and other parts of the country, along with the attendant financial rewards. Wyman was an astute businessman and entrepreneur. He saw an abundance of waterpower at his disposal and the need for electricity expanding both within and outside of Maine. This was the beginning of the Central Maine Power Company, and as such the beginning of the road that would eventually lead to the inundation of the villages of Flagstaff, Dead River, and Bigelow.

Walter Wyman's dream was to build a hydroelectric generating facility at the Forks and flood land upstream, creating a surplus of electricity and selling much of it out-of-state. Standing in his way was then-legislator and later governor Percival Baxter, who wanted to keep the power generated in Maine within the state in order to encourage industrial development and to better the lives of the citizens within the state. He had observed many of the natural resources of the state being given away or sold at bargain prices to large companies, and had chastised both the people of the state and its leaders for this process. Baxter realized the need for and supported the development of electric power in the state but strongly believed that it should benefit the residents first and foremost. Additionally, the Fernald Law, enacted in early 1910, named for Gov. Bert M. Fernald and supported by Baxter, also prohibited electric power generated within the state to be sold outside the borders of the State of Maine. Ultimately, the Great Depression and the Fernald Law would allow Wyman to create great profits within the state by buying struggling manufacturing facilities and then selling them the power required to continue operating. Wyman's buying these struggling plants in order to supply them with power ultimately resulted in the continuous operation of these plants and a steady supply of jobs for the people of Maine while much of the country struggled with high unemployment. It is likely Maine fared far better than most states during the Depression because of this maneuver.

Wyman's dream of building a dam at the Forks never materialized because it became financially impractical to flood state-owned land. It would be far easier and less financially demanding to build three dams—one on the Kennebec at Bingham, one at the outlet to Indian Pond, and one at Long Falls on the Dead River. The latter would necessitate the flooding of the villages of Flagstaff, Dead River, and Bigelow.

In Wyman's estimation, the creation of Flagstaff Lake was critical to the power needs of Central Maine Power and the state of Maine. By controlling the frequent flooding and spring runoff long associated with the Dead River, storing the estimated 12 billion cubic feet of water that annually flowed down the Dead River and releasing it over time into the Kennebec, a constant supply of electricity could be generated for the ever-growing number of manufacturing plants downriver. Record floods in 1900, 1906, 1917, and 1923 added support to Wyman's contention that flood control on the Dead River was essential not only for electrical generation purposes, but also for saving the millions of dollars worth of damages that these floods were regularly causing along the Kennebec River.

In 1923, the Maine Legislature initially authorized the building of Long Falls Dam on state land. This bill was vetoed by Governor Baxter, who overnight proposed a similar bill with the addition of a provision for a long-term lease of the state land required for the construction site of the dam. A tremendous fight ensued between the governor and the legislature that lasted until 1927, after Baxter's term had expired, when the bill was ratified by the legislature. This condemned a 25-mile stretch of the Dead River, allowing the Kennebec Reservoir Company to seize property by right of eminent domain, lease property belonging to the state, and construct a dam at Long Falls. This act sealed the fate of the three small villages along this stretch of the Dead River.

Central Maine Power eventually became the only company able to continue with this proposal, and in 1930, it began purchasing the land that would be flooded. In the late 1930s, the Dead River Storage Company was formed, which consisted of Central Maine Power Company, Great Northern Paper Company, and the Hollingsworth and Whitney Company. Discussions were initiated regarding installation of a turbine in the newly proposed dam. It was determined that it was not feasible at that time due to the perceived large fluctuation in the water levels in the proposed lake. It was argued that the water levels would be too low during many months and would make the operation of a turbine impractical. In 1948 and 1949, CMP began clearing and burning the flowage area in preparation for creating Flagstaff Lake in 1950, when the gates were closed on the newly constructed Long Falls Dam. The lease for state land fought for by Governor Baxter in 1923 is still in effect today and partially supports the Department of Conservation.

Despite the many early stories and political spin of the 1930s and early 1940s regarding the need for this project, the people of these small villages only reluctantly parted with their property. They were not at all anxious to sell their property at any price, much less accept CMP's compensation offers, considered modest at best. The residents of these villages eventually became resigned to their fate. Most residents had been living with the idea of the dam for several years, but many were shocked and felt betrayed that they should have to be relocated so that people downstream on the Kennebec could have a better life. During some of the debate over the 1923 bill Senator Eaton of Oxford stated "Which is better for the state of Maine, a real development worth while or that country up there as it is today? Did any property owners up there come down here and raise any objection to this bill? Not one." One irony of this situation is that in their entire existence, the villages of Flagstaff, Dead River, and Bigelow never had central electrical service.

When the gates to the dam were eventually closed and the lake formed, several of the property owners had not settled with CMP on a price for their property. Their buildings could not therefore be razed nor their trees removed prior to flooding. This gave rise to a great deal of speculation and rumors about some residents holding out and going down with the ship. No one drowned during the flooding by refusing to leave, and no church steeples were sticking above the water, but there were in fact some buildings (seven in total belonging to three different owners) that were flooded out due to no fair settlement having been reached regarding compensation for the property. These buildings remained in the lake until the following winter, when crews went out on the ice and cut the remaining trees and burned all buildings.

Historian Dr. David Smith, University of Maine professor emeritus, summed it up this way in the Maine Public Broadcasting video titled *Power Lines*. "For many Mainers, Flagstaff now is a symbol of that other Maine, that 19th-century Maine; here we have that 19th-century Maine being drowned by the forces of the modern world, being drowned eventually by electricity. Look at the two of them and you get that feeling that this is where the old Maine and the new Maine came together, under the waters of Flagstaff. It is necessary to destroy things to make progress, but it doesn't diminish the impact on some."

In no small respect, the people of this region are facing similar issues today regarding electrical power requirements and consumption. As renewable technology is developed (i.e. wind power), the people living in Maine's western mountains are faced with similar issues as the former residents of Flagstaff, Dead River, and Bigelow. Although they are not being asked to give up their homes, many residents feel they are now being asked to give up what they believe is a piece of what makes this area special—its natural beauty. They feel they are being asked to sacrifice some of their inheritance so that other people might benefit financially, while at the same time being asked to accept the degradation that is inundating the area's mountaintops. We must ask ourselves, "What is the price of power?"

One

BIGELOW PLANTATION

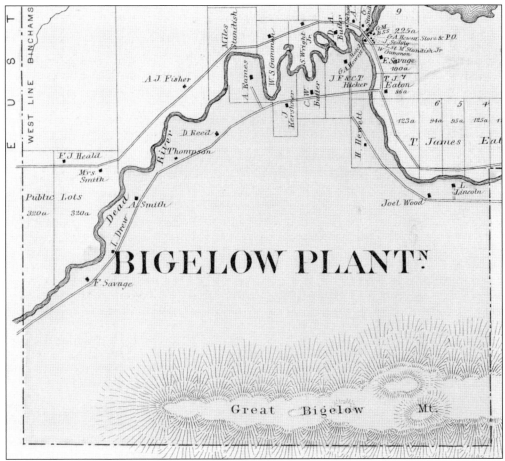

The smaller settlement of Bigelow, shown in this 1883 map of Somerset County, was directly across the Dead River from Flagstaff. Organized as a plantation in the early 1870s, it never expanded like the other two villages, reaching a peak population of around 57 in 1900. It disbanded as an organized plantation in the early 1920s. Most of this township is now protected as the Bigelow Reserve and is administered by the Bureau of Public Lands. (Courtesy of Maine State Archives.)

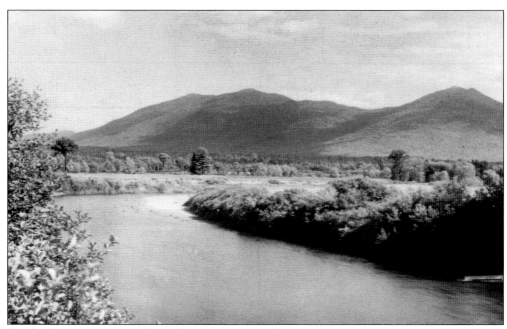

Pictured here is the placid Dead River showing the Bert Heald farm to the right and the Walter Hinds farm in Flagstaff on the left. (Courtesy of DEW.)

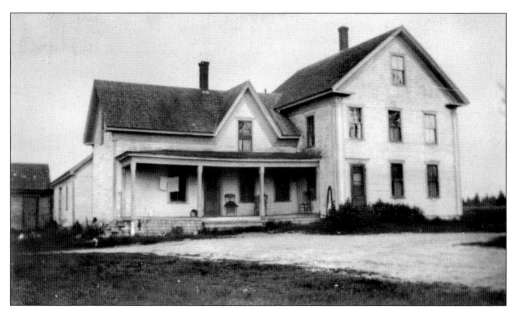

This is a 1940s view of the Leon Savage farm located along the Old Flagstaff Road. This is where the old Stratton dump was located after the creation of Flagstaff Lake. (Courtesy of DRAHS.)

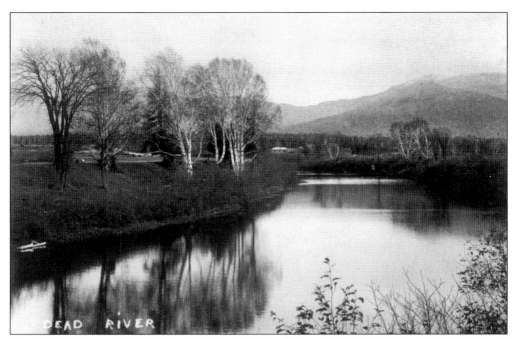

The Charles Savage farm was located along the Dead River. Note the Bigelow Mountain Range in the background. (Courtesy of Earl Jr. and Wendy Wyman.)

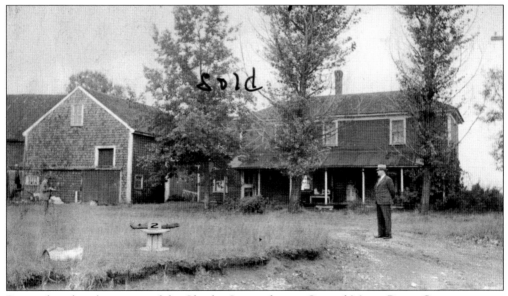

Pictured in this closer view of the Charles Savage farm is Central Maine Power Company agent B. J. Whitney, whose job it was to negotiate the purchase of the properties impacted by the proposed Flagstaff Lake. (Courtesy of DRAHS.)

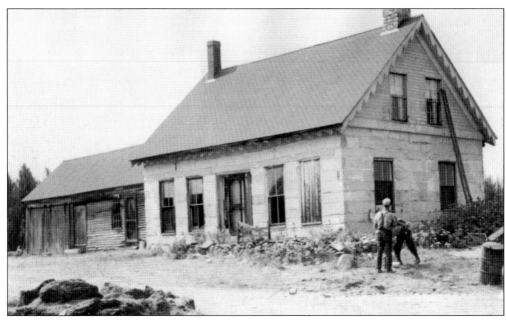

Locally known as the Stone House, this home was constructed of granite mined from the side of Mount Bigelow by the Kershner family, who were immigrants from France. One of the family purportedly was the personal bodyguard or the son of a bodyguard to Napoleon Bonaparte. This house, although partially dismantled, sat on the edge of the current lakeshore and could possibly have been preserved if not for shoreline erosion. (Courtesy of DEW.)

The Bigelow schoolhouse served the primary grades, with the older students crossing the river to attend Flagstaff High School. This building was relocated to Stratton village and is currently a private residence. (Courtesy of DEW.)

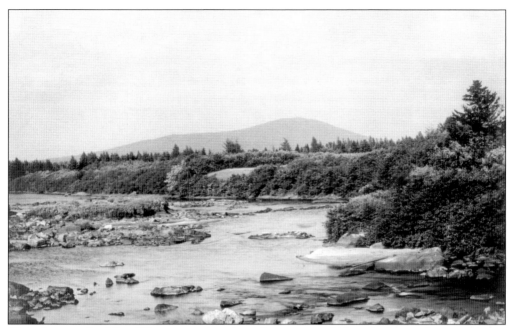

This photograph of Dead River was taken from the vicinity of Myers Lodge at what was known as Fisher Rips. (Courtesy of DEW.)

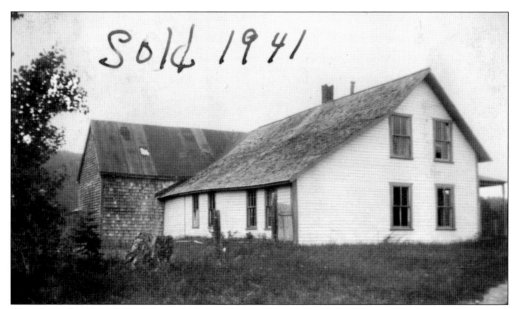

Here is a photograph by Central Maine Power Company of the Florin Ellis property. Central Maine Power took photographs of all the property it purchased. (Courtesy of DRAHS.)

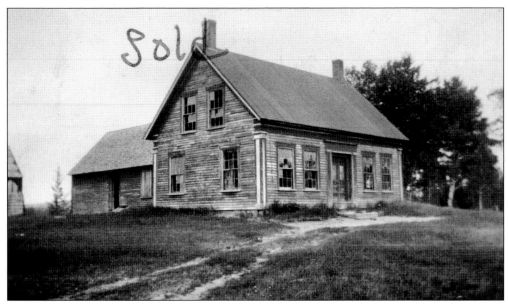

This is another Central Maine Power Company photograph of the Charles C. Lincoln farm. Most buildings in the area were not maintained subsequent to the realization they would be demolished when the dam was built. The residents knew they would receive no additional compensation for their efforts, and in fact, property declined in value the closer time came for the lake to be created. (Courtesy of DRAHS.)

This house on the Dead River in Bigelow Plantation was owned by Peter Wahl. (Courtesy of DRAHS.)

Two

DEAD RIVER PLANTATION

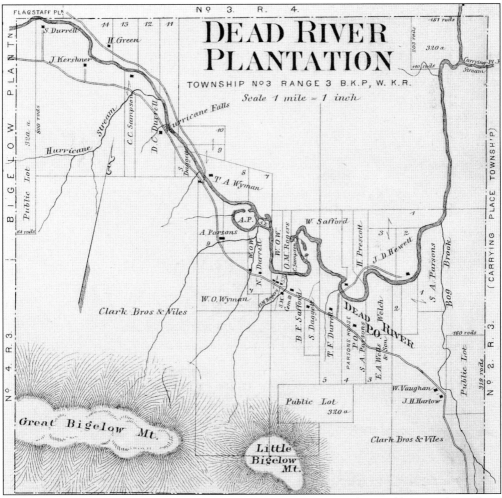

Dead River was an organized plantation at the foot of Mount Bigelow and consisted mostly of farmers, loggers, and lumbermen. It was organized as a plantation in 1873 and had its own post office, school, and several boardinghouse establishments that catered to hunters and fisherman. It reached a peak population of 113 between 1880 and 1900. There were approximately 75 people living here when the dam at Long Falls was built in 1949. (Courtesy of Maine State Archives.)

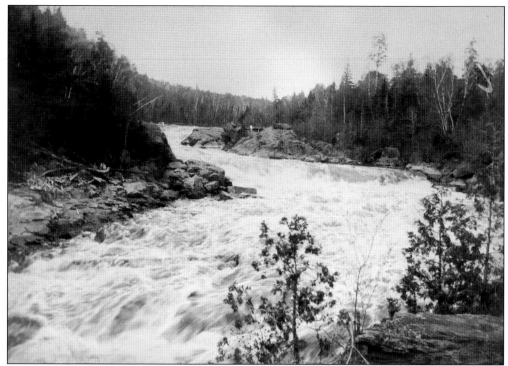

This old photograph of Long Falls on the Dead River was taken before the Long Falls Dam was constructed just above these falls, which created Flagstaff Lake. (Crockett and Hartwell photograph, courtesy of DRAHS.)

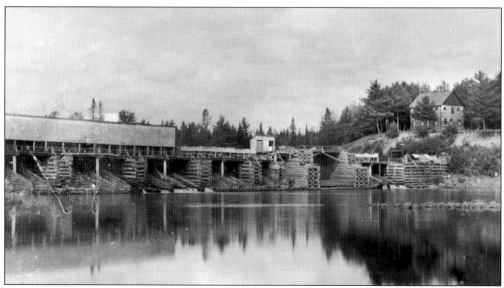

The Dead River dam was located just upstream from Grand Falls and was used exclusively for the log driving business. The Payson house shown here was named for Payson Viles and was used to house loggers and river drivers. There was a prominent sign over the door pronouncing, "No Calked Shoes Allowed Inside." (Courtesy of DRAHS.)

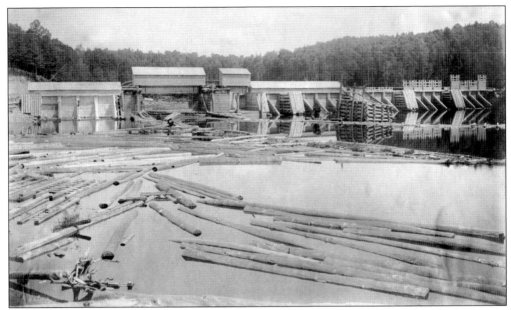

The early Dead River dam was utilized by log driving companies to control the flow of water while moving logs down river. This ceased to be a functional dam when long log driving on the river was abandoned. (Courtesy of DRAHS.)

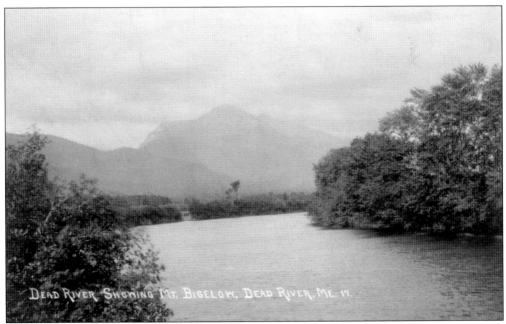

DEAD RIVER SHOWING MT. BIGELOW. DEAD RIVER, ME. 17.

Here is the Dead River and Mount Bigelow as it appeared on a postcard postmarked in 1917. (Courtesy of Thomas MacDonald.)

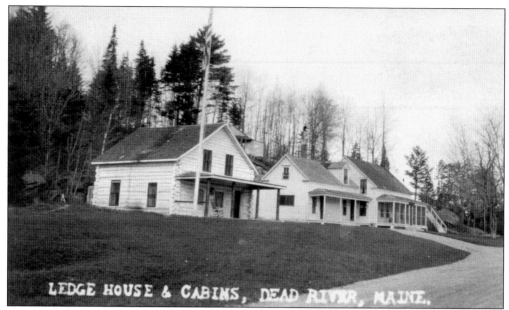

The Ledge House and cabins were a popular recreational stop for hunters and fishermen. It got the name from a large rock outcropping, or ledge, located behind these buildings in this photograph, which are still distinguishable today. The Harlow brothers owned this establishment in the late 1800s, as well as several other similar businesses, such as the Flagstaff Hotel. (Courtesy of Thomas MacDonald.)

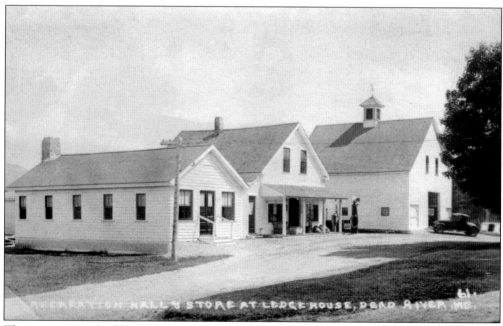

There were many buildings associated with the Ledge House. This photograph shows the store, the recreation hall, and the barn. (Courtesy of DEW.)

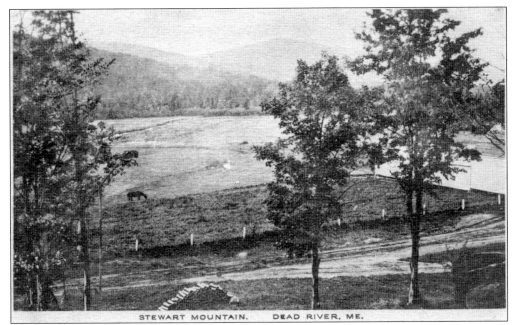

STEWART MOUNTAIN. DEAD RIVER, ME.

This view of pastureland from the Ledge House shows Stewart Mountain in the background. Today this area is covered by Flagstaff Lake from about where the trees are in the foreground to the other side of the pasture. (Courtesy of Thomas MacDonald.)

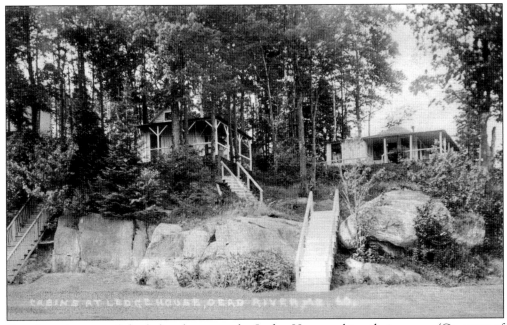

Seen here is some of the ledge that gave the Ledge House cabins their name. (Courtesy of Thomas MacDonald.)

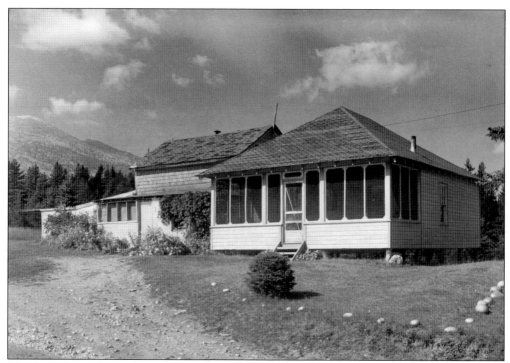

The Benjamin Fred and Methyl Safford home was moved to the town of Embden, where it is a private residence today. (Courtesy of DRAHS.)

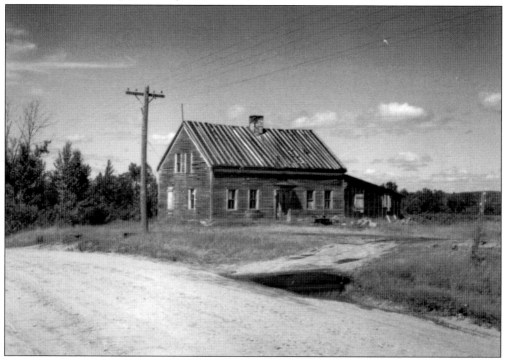

The Benjamin Franklin Safford house is shown here around 1940, after it had been purchased by Central Maine Power. (Courtesy of DRAHS.)

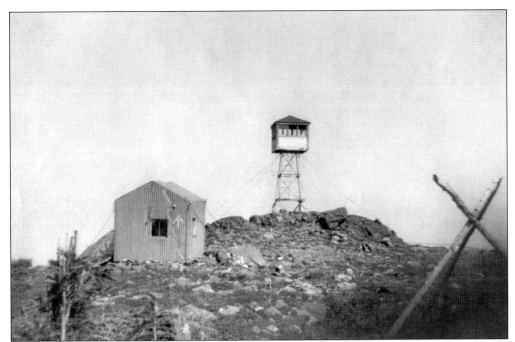

Duluth Wing took this photograph of the Mount Bigelow fire tower and lightning shack in 1947 during one of his first days on the job as a fire tower watchman for the Maine Forest Service. The lightning shack was a place watchmen could seek haven during a lightning storm rather than being more exposed to a lightning strike up in the fire tower. This was known as East Peak in those days. (Courtesy of DEW.)

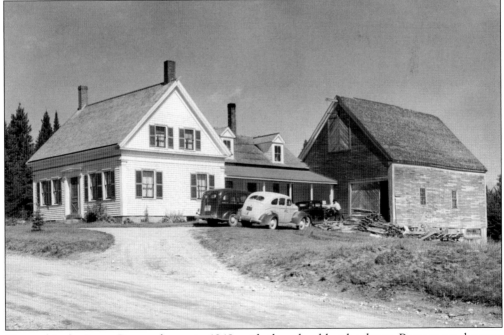

Pictured is the Leroy Parsons house in 1948, with the school bus he drove. Parsons can be seen bending over the engine compartment of his car in front of the barn. (Courtesy of DRAHS.)

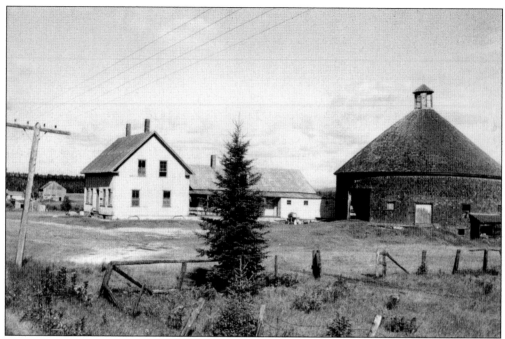

The Charles T. Rand farm, with the renowned round barn, can be seen here. Rand had built his round barn by 1911, and it was 80 feet across and 60 feet high. Although not flooded out by the lake, the barn was later partially dismantled and accidentally burned. (Courtesy of DRAHS.)

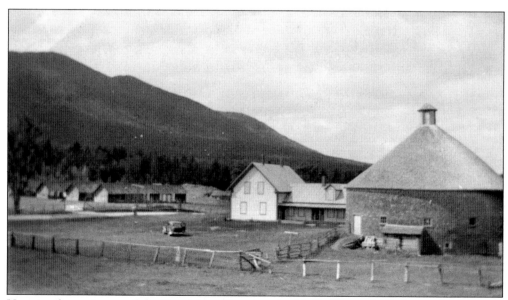

Here is a later picture of the Rand farm showing the H. G. Winter Mill drying sheds in the background. There were two lumber mills located near this famous landmark building. S. D. Warren eventually purchased all this property and closed and shuttered the house and barn. (Courtesy of DRAHS.)

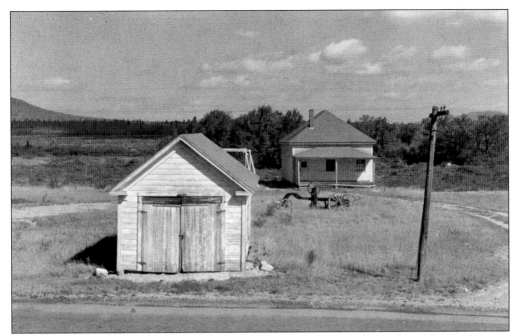

The Dead River town garage with an old-fashioned road grader is shown here. The building in the background is the Dead River School, which was built in 1915 by Charles T. Rand to replace an older school building. This school building was eventually moved to Stratton and was used as that town's post office for many years. It is now a private residence in Stratton village. (Courtesy of DRAHS.)

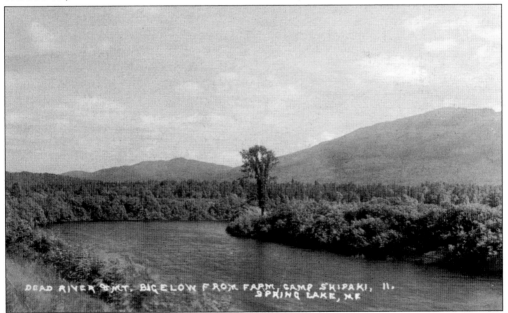

DEAD RIVER & MT. BIGELOW FROM FARM, CAMP SKIPAKI, II.
SPRING LAKE, ME

A view of the Dead River and Mount Bigelow looks east from Camp Skipaki, which was associated with the Morgan farm. Native Americans called this river, the mountain range, and the surrounding area *Tiaouiadicht*, as did John Montressor on the map that was used by Benedict Arnold during his march to attack Quebec City. (Courtesy of Thomas MacDonald.)

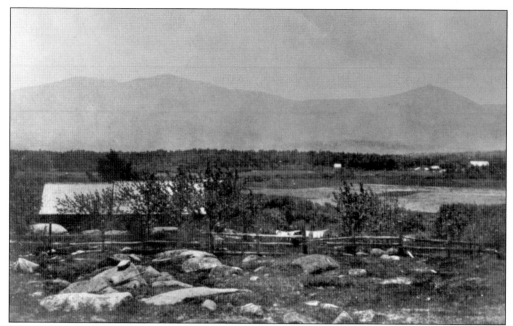

The Arthur Rogers farmhouse is seen here with the Peter Wahl farm in the background. The farm was later purchased by financer J. Pierpont Morgan, along with 13,000 acres of timberland stretching from this point northward, including the area around Spring Lake. (Courtesy of DEW.)

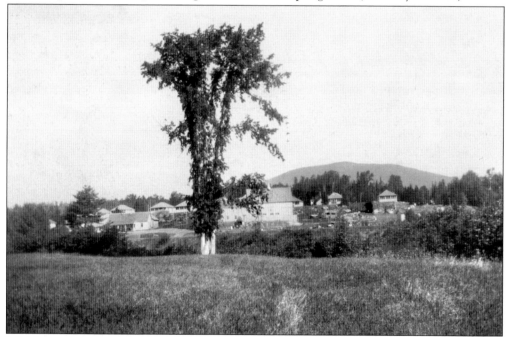

J. P. Morgan bought and rebuilt the Arthur Rogers farm in the 1920s and renamed it Camp Elliot Bacon after his business partner, who was killed during World War I. This farm was used to supply the Spring Lake Camps, a favorite recreation facility used by Morgan's employees. The Arthur Rogers house was the nearer building to the left of the large Elm tree. Many of the camps in the background have been moved to various locations in the Eustis area. (Courtesy of DRAHS.)

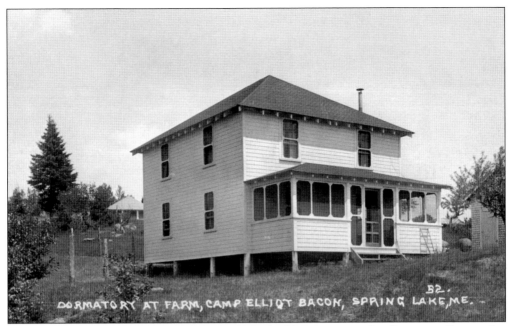

This was a dormitory at Camp Elliot Bacon. The building was moved to Stratton village and is used as a private residence today. (Courtesy of DRAHS.)

The Spring Lake Camps were also owned by J. P. Morgan and were part of his larger 13,000-acre Spring Lake Land Corporation. This is a photograph of the post office building at this set of camps. Many local people were employed there as seasonal help. (Courtesy of June Leavitt Parsons.)

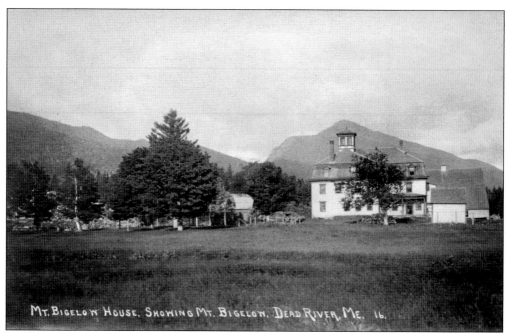

The Mount Bigelow House is seen here with majestic Mount Bigelow in the background. Sam Parsons bought a tavern here in 1866, and in 1886, he rebuilt it into this two-story Colonial-style mansion and named it the Mount Bigelow House. It was a popular stage stop, tavern, lodging house, and hunting destination. (Courtesy of DEW.)

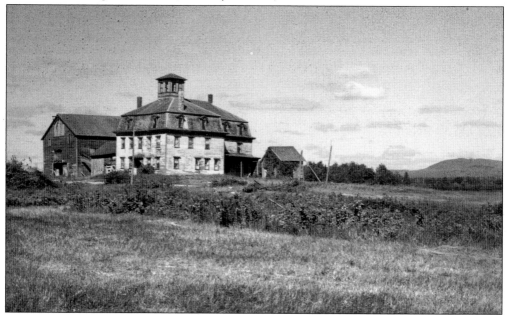

In 1914, Philander "Fud" Taylor sold his home in Flagstaff (the Chatfield House) and bought the Mount Bigelow House, moving his family and belongings in a hayrack. After that the house was known as the Fud Taylor farm. He continued to run it as a boardinghouse and hunting destination for many years, and eventually it was purchased by CMP and demolished. (Courtesy of DRAHS.)

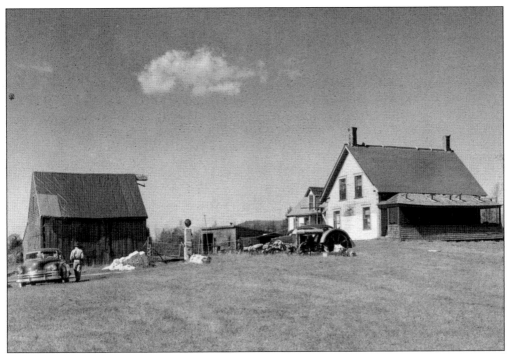

The Clyde Burbank farm contained a fairly typical set of farm buildings that were scattered throughout the Dead River Valley. (Courtesy of DRAHS.)

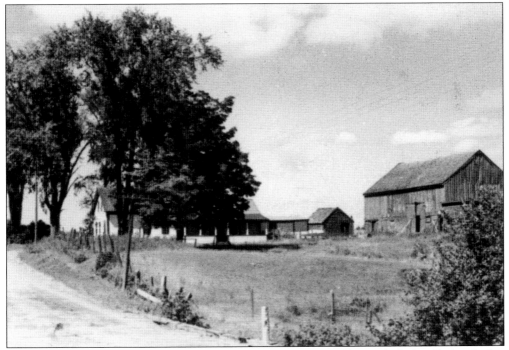

Originally this was the William Wyman farm. It was later owned by Fred Blackwell, then by his son Herbert Blackwell, and finally by the widow Bertha Hulseman. It was occupied by the Frank Donahue family when it was flooded out in 1950. (Courtesy of DEW.)

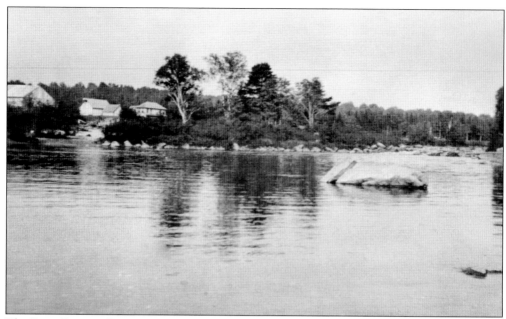

The Danville Durrell farm is seen here prior to 1914. It was located on the south side of Hurricane Falls on the Dead River. There is currently an island in Flagstaff Lake called Hurricane Island, named for this set of falls. (Courtesy of DEW.)

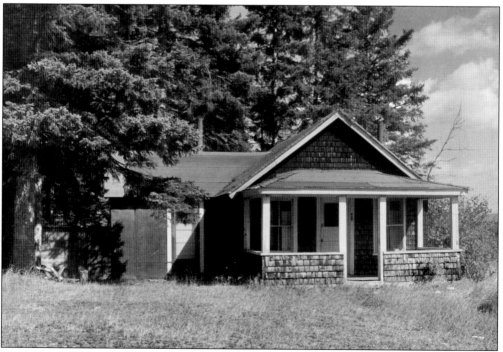

The home of Herbert Rogers was located on the H. G. Winter Mill property near the Rand farm. (Courtesy of DRAHS.)

The home of Lee and Gladys Rogers was located in Dead River Plantation behind the home of Benjamin and Mythel Safford. This camp was never flooded and is situated right on the shore of the lake today. (Courtesy of DEW.)

The Phillip Wing house was moved to Lexington and is a private residence today. (Courtesy of DRAHS.)

The Russell and Emma Safford farm is seen here. Their son Benjamin Fred Safford wrote an important history of Dead River Plantation and Flagstaff Plantation using many early town records. (Courtesy of DRAHS.)

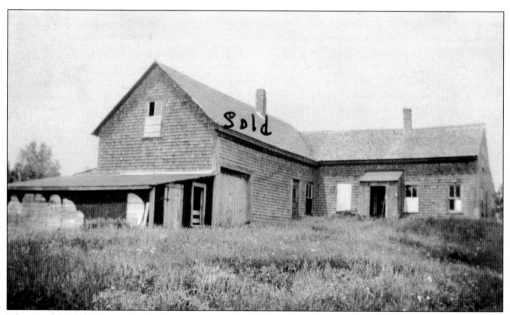

The Goddard farm, also referred to as the Ferry farm, is where a ferry and floating bridge was located in the early days to transport people across the Dead River to Flagstaff. This floating bridge was still used for many years, even after the construction of the covered bridge in Flagstaff. (Courtesy of DEW.)

Wendell Wing (left) and Eddie Donahue are at the Donahue house with the C. T. Rand farm in the far background and the Arthur Wing house on the right. (Courtesy of Wendell Wing.)

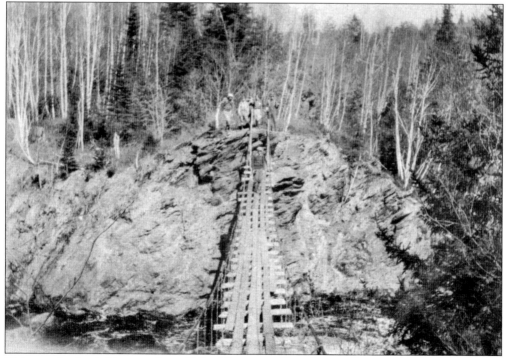

This was the footbridge over Long Falls. (Courtesy of June Leavitt Parsons.)

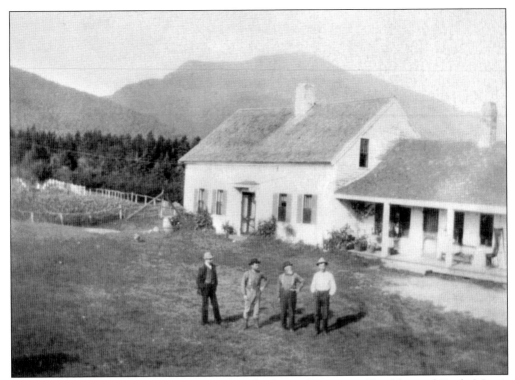

Three generations of Saffords are pictured at the farm of Benjamin Franklin and Emily Morris Safford. From left to right are A. Bailey, grandson Benjamin Fred Safford, son Benjamin Franklin Safford, and father Russell Safford. (Courtesy of Earl Jr. and Wendy Wyman.)

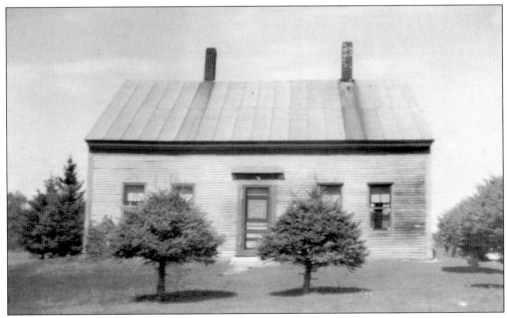

The Bert Witham house can be seen here. (Courtesy of DEW.)

Three

FLAGSTAFF PLANTATION

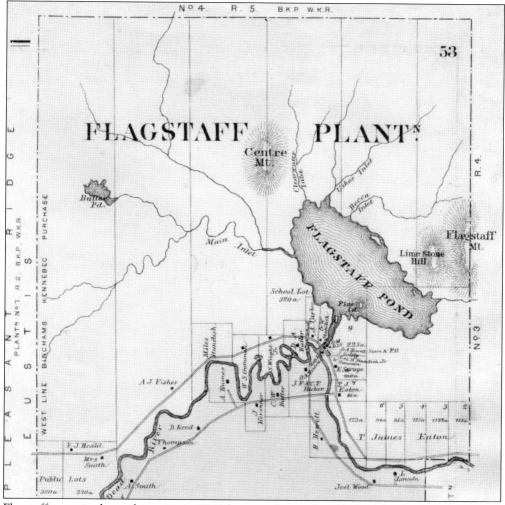

Flagstaff, organized as a plantation in 1865, became the unofficial hub of the three settlements. It had two general stores, a blacksmith shop, a sawmill, a church, a high school, a Masonic lodge, a pool hall, a barber, and above one store there was even a dance floor where silent movies were shown. The 1940 census listed the population at 143. There were 44 buildings and 25 families displaced when the Long Falls dam was closed in the spring of 1950. (Courtesy of Maine State Archives.)

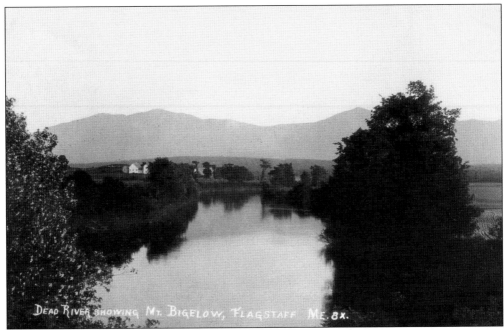

This is a postcard picture taken of the Dead River and Bigelow Mountain sometime before 1934; it can be dated because the Leon Wing farmhouse on the left burned in 1934. The next barn to the right would have been the Ray Viles farm (which later became the Myron Stevens farm and then the Perley Myron Stevens farm). (Courtesy of DEW.)

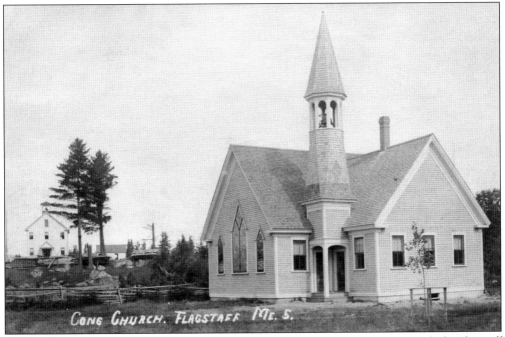

The Flagstaff Congregational Church, built by Charles T. Rand in 1902, is shown with the Flagstaff schoolhouse in the background. This is a postcard picture taken sometime before 1927; it can be dated because the school burned in the spring of 1927. (Courtesy of DRAHS.)

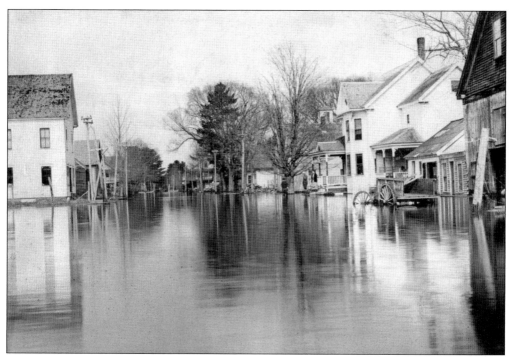

This westerly view of Main Street in Flagstaff village shows the flood of April 28–29, 1923. (Photograph by A. E. Wright, courtesy of DRAHS.)

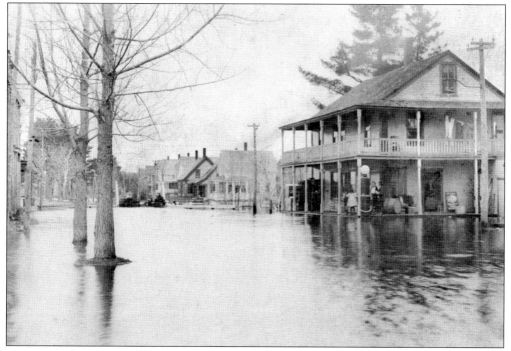

Here is another westerly view of the 1923 flood showing Main Street in Flagstaff village. The C. C. Lincoln store is on the right. Note the logs piled on the bridge to add weight in order to prevent it from floating off. (Courtesy of DRAHS.)

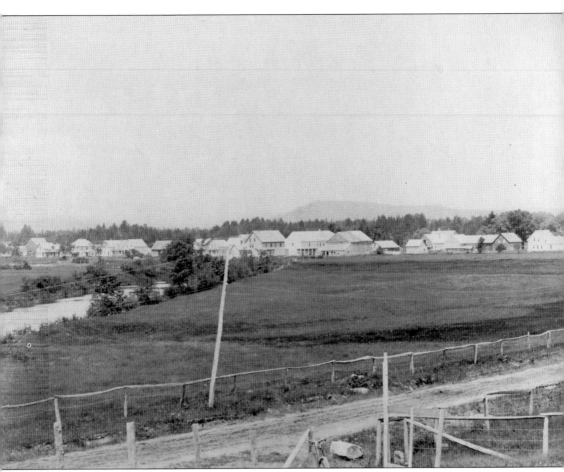

Pictured on these two pages is a 1916 panoramic view of Flagstaff village. (Courtesy of DRAHS.)

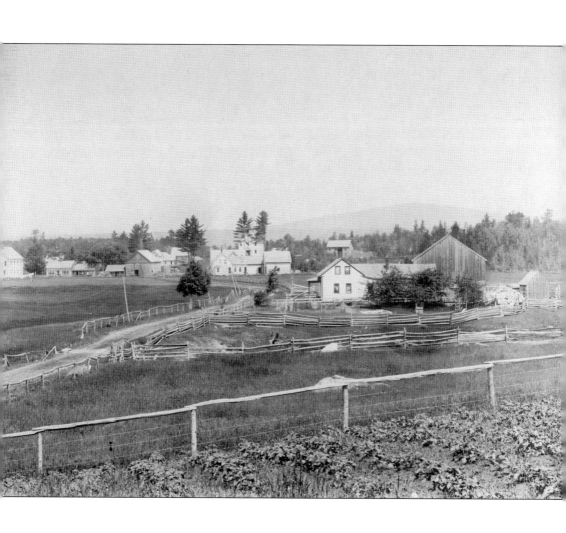

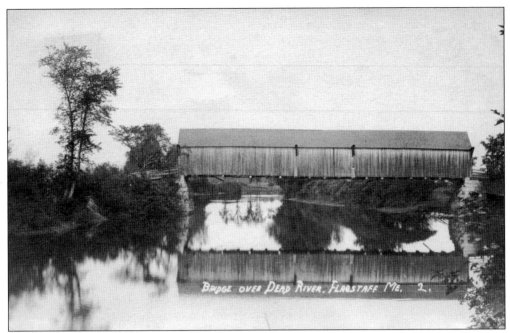

The covered bridge over the Dead River is just downriver from Flagstaff village. This covered bridge was originally constructed in 1873. (Courtesy of DEW.)

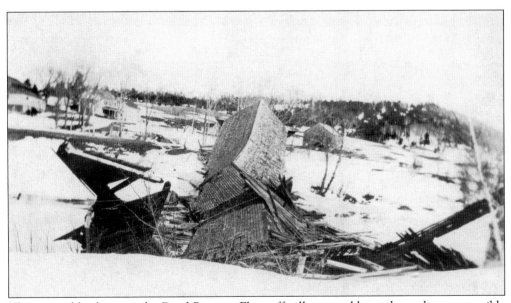

The covered bridge over the Dead River at Flagstaff village was blown down due to a terrible wind on March 7, 1922. In the background is what was at that time the Ray Viles farm, with the top of Jim Eaton Hill in the far background. (Courtesy of DEW.)

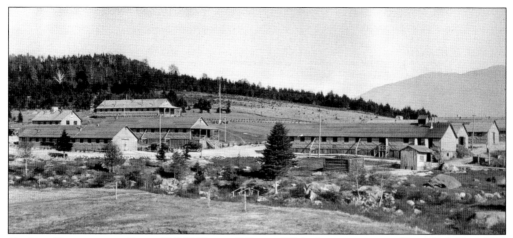

Civilian Conservation Corps (CCC) Flagstaff Camp, 178th Company, existed here from June 1933 to September 1935. Under the supervision of the Maine Forest Service, these men were responsible for many construction projects. CCC volunteers built fire lines for forest fire suppression efforts, trails to fire towers on Mount Bigelow and Kibby, strung miles of forest service telephone lines, and constructed truck trails at Long Falls and Sandy Stream, as well as making many bridges and lunch grounds throughout the area. (Courtesy of DRAHS.)

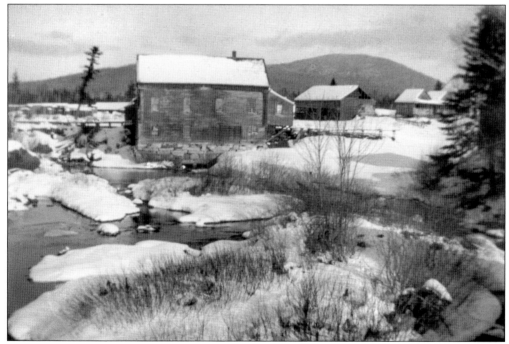

This was the old gristmill in Flagstaff village, which was situated on the stream coming out of Flagstaff Pond. This image was likely taken during the time period when Arthur Rogers owned it. On the far right are some cabins, which were part of the Warren Wing house. This house is currently a residence located on Eustis Ridge. To the left of the mill are stacks of boards or squares from the Jenkins and Bogart Mill. (Courtesy of DEW.)

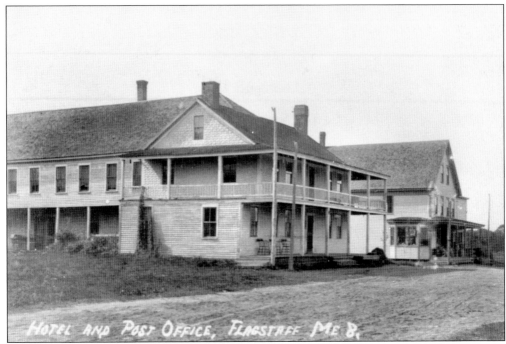

Here is a postcard picture of the Flagstaff Hotel, which was torn down sometime between the fall of 1927 and spring of 1928. Myles Standish caused a tavern to be built here in 1842, and later it became the Flagstaff Hotel with an addition on the back. By the fall of 1912, Jim Harlow had bought it, advertising, "You can hunt by canoe right from the hotel." (Courtesy of DEW.)

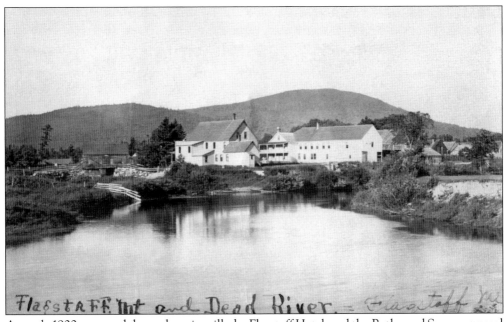

An early-1900s postcard shows the gristmill, the Flagstaff Hotel, and the Butler and Savage general store, built in 1888 by David Butler. This view is looking down the Dead River where Mill Stream (the outlet to Flagstaff Pond) meets the river adjacent to the general store. (Courtesy of DEW.)

The Alvin P. and Eva Parsons Wing house and barn are shown here. It was originally built by Will Gammon and his son Will for Myles "Square" Standish. This was one of the first homes built in Flagstaff. (Courtesy of DRAHS.)

The picnic area at Al's Pines is photographed here. Alvin "Al" Wing had a stand of white pine trees across the road from his residence, and he kept a picnic area there for everyone to enjoy. A short walk down through the field brought swimmers to a nice beach on the Dead River. (Courtesy of DRAHS.)

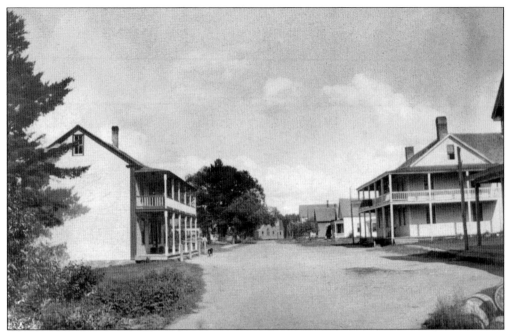

A postcard postmarked 1909 was taken from the Mill Stream Bridge (locally known as "the little bridge") looking easterly down Main Street in Flagstaff village. The C. C. Lincoln Store is on the left, the Butler and Savage general store is in the shadows on the right, and adjacent to that is the Flagstaff Hotel. At the far end is the Flagstaff Congregational Church. (Courtesy of DRAHS.)

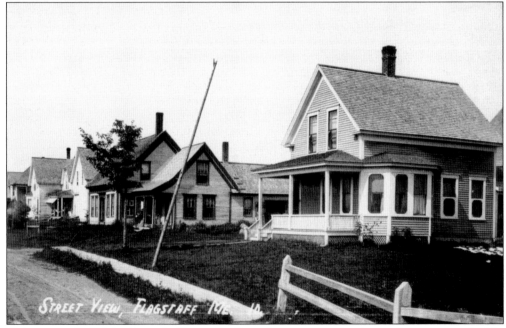

This postcard of Main Street in Flagstaff village shows a westerly view and was postmarked in 1911. From left to right are the Viles house, the Almon "Tripe" Deming house, the Cliff "Shep" Butler house, and the Carl and Mae Savage house. Telephone service first arrived in this area in 1889. (Courtesy of Thomas MacDonald.)

This is another westerly view of Main Street in 1948 or 1949, with the E. J. Leavitt general store on the left, the Hazen Ames pool hall on the right and the Wing boardinghouse on the far right. (Courtesy of June Leavitt Parsons.)

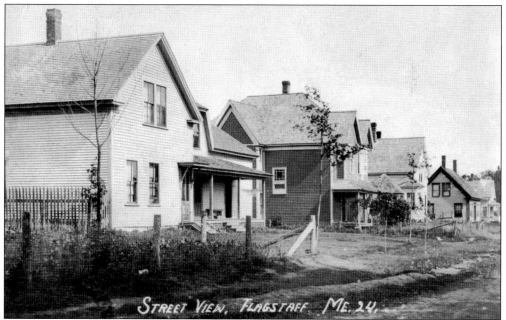

STREET VIEW, FLAGSTAFF ME. 24.

On the back of this postcard, which features a Flagstaff street view, it reads, "This is Main St. There is only one Street." From left to right are a house owned by Al Wing, the Viles house, the Almon "Tripe" Deming house, the Cliff "Shep" Butler house, and the Carl and Mae Savage house. (Courtesy of DRAHS.)

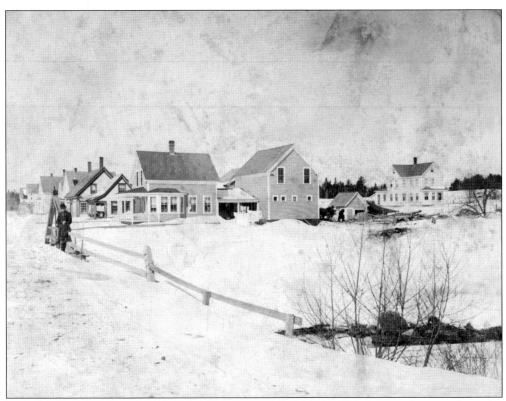

Harry Lincoln and a young unidentified boy are posing on the Mill Stream Bridge over the outlet to Flagstaff Pond. Pictured is the western portion of Main Street, with the Carl and Mae Savage home in the foreground and the Chatfield House on the far right. (DEW.)

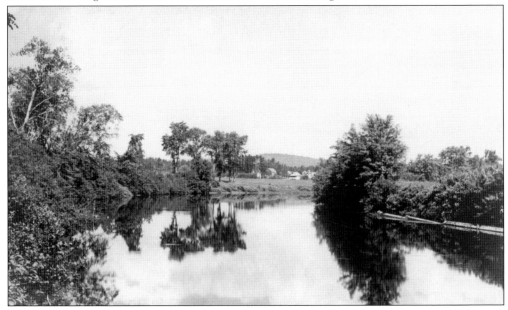

This was the view one saw when standing at the covered bridge looking upriver toward Flagstaff village. Alvin P. Wing's barn can just be made out in the distance. (Courtesy of DEW.)

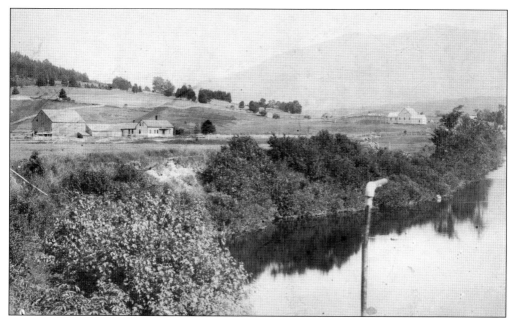

An early-1900s photograph shows what was then the Benjamin E. "Deke" Savage farm (left) and the Leon F. Wing farm (right). The B. E. Savage house contained the first school in Flagstaff during the mid-1800s. One can just make out the headstones in the Flagstaff Cemetery to the left of the Leon Wing barn. Mount Bigelow is in the far background, Jim Eaton Hill lies behind the Savage farm, and the Dead River appears on the right in this photograph. (Courtesy of June Leavitt Parsons.)

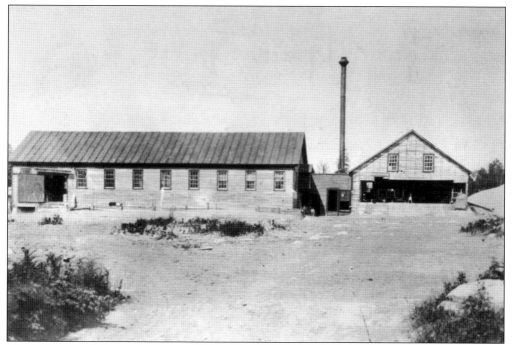

The Jenkins and Bogart Mill is seen on a postcard postmarked 1907. This mill was located on the outlet to Flagstaff Pond and used steam for power. (Courtesy of DEW.)

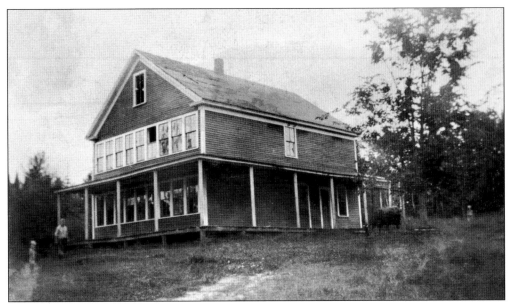

The boardinghouse for the Jenkins and Bogart Mill workers is shown here. When the Flagstaff school burned in 1927, this became the town schoolhouse, known as "the Red Schoolhouse" because of its color, until a new school was built in 1931. (Courtesy of DRAHS.)

This building was known as "the Yellow Schoolhouse." It was the second school in Flagstaff and the first one built purposefully as a schoolhouse in the 1800s. During later years it belonged to Cliff Butler and sat right next to the Viles Timberland Mill at "Shep's Logan." (Courtesy of DEW.)

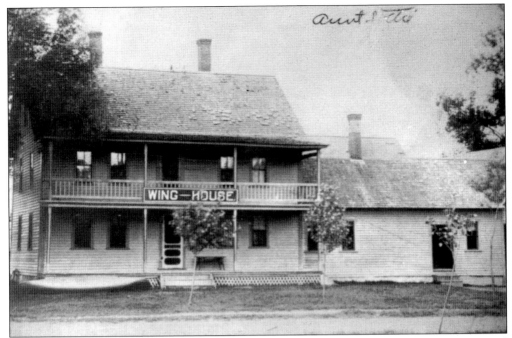

Known as the Wing House, this boardinghouse was owned by "Captain" Clifford E. Wing. He and his wife, Ettie Bachelder Moody Wing, ran it. The canoe in this picture was one of his handmade canoes and was named *Clearwater* after Clearwater Brook. This postcard was from Ettie Wing to Evelyn Leavitt at the birth of June Leavitt, with the message, "Hope this finds you and baby fine." (Courtesy of KRW.)

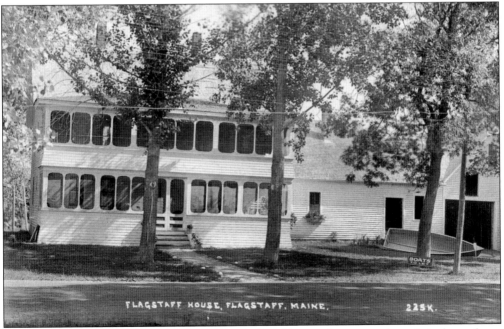

A more modern view of the Wing House with the addition of a screened porch is shown here. (Courtesy of KRW.)

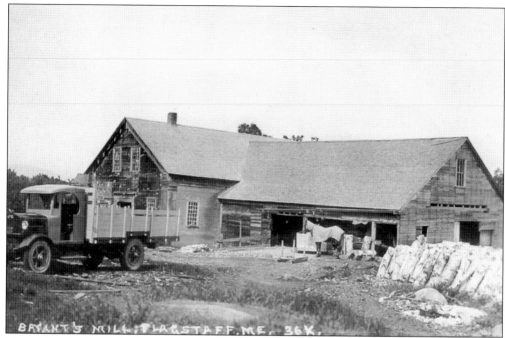

Shown here is the H. G. Bryant Mill. Harry Greenleaf Bryant came from Bethel and bought this mill in 1926 from Arthur Rogers. Pictured are Harry's Indiana truck and his horse named Roger. (Courtesy of Lydia Bryant.)

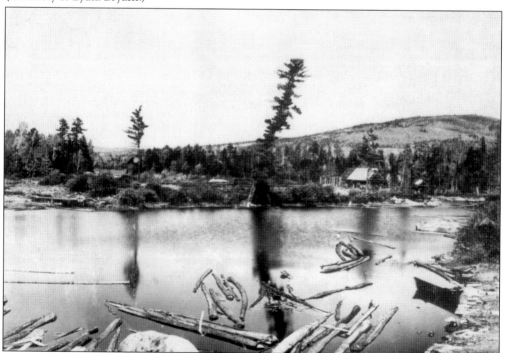

Mill Pond is seen above the H. G. Bryant Mill on the outlet of Flagstaff Pond with Flagstaff Mountain in the background. The building pictured is an old drying shed that was once part of the Jenkins and Bogart Mill. (Courtesy of DEW.)

The H. G.
Bryant Mill
is shown
in here.
(Courtesy of
DRAHS.)

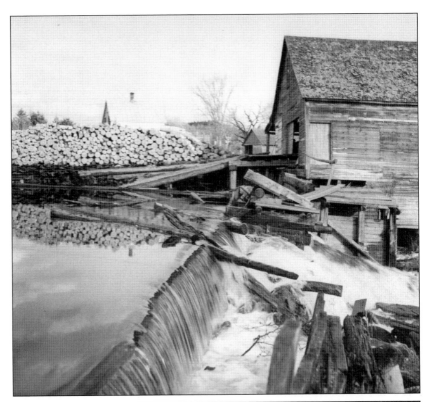

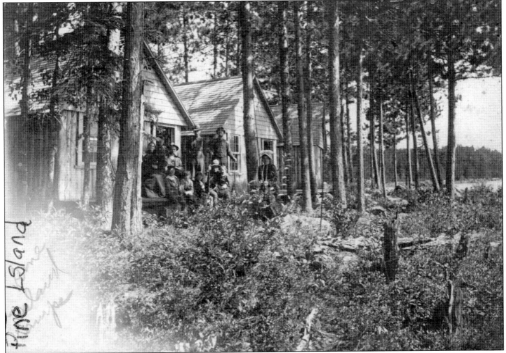

This is photograph, taken prior to 1900, shows a set of cabins on Pine Island on the north shore of Flagstaff Pond. (Courtesy of DEW.)

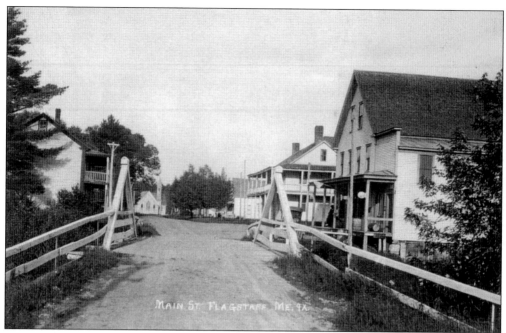

Here is a 1920s view of Main Street in Flagstaff. (Courtesy of DRAHS.)

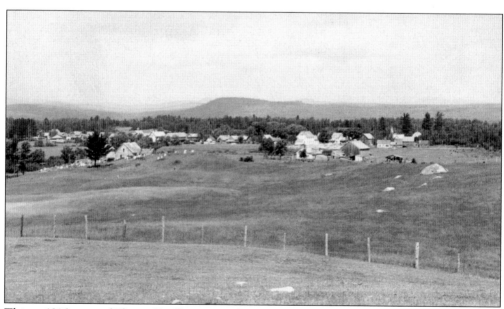

This c. 1916 view of Flagstaff village was taken from the fields on Jim Eaton Hill. (Courtesy of DEW.)

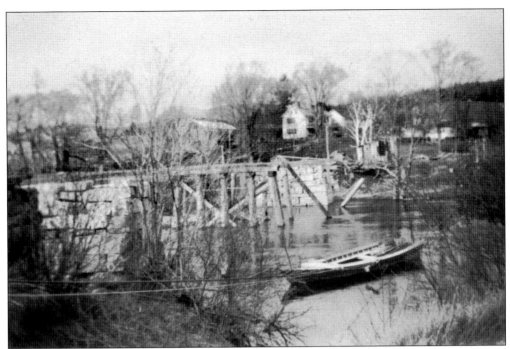

A spring of 1936 view of the covered bridge abutments is shown here with the Stevens farm in the background. There was a temporary floating bridge here from the time the covered bridge blew down in 1922 until the time when a new bridge was constructed in 1936. (Courtesy of DEW.)

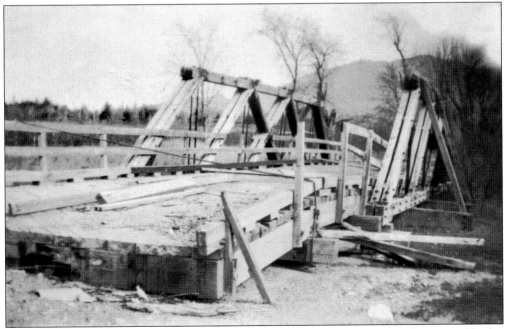

In 1936, the Works Progress Administration constructed a new bridge where the covered bridge across the Dead River used to be. The project foreman was Walter Scammon, and it became known locally as "the Big Bridge" to differentiate it from "the Little Bridge" across Mill Stream in Flagstaff village. (Courtesy of DEW.)

Cliff Wing poses at his booth in the Mechanics Building at the Boston Sportsman Show in the 1930s. He advertised hunting and fishing in the Flagstaff area, as well as his cabin-building business. During the show he built a log cabin with just an ax and bucksaw. The log cabin birdhouses he made with a jackknife. (Courtesy of DEW.)

The Almon "Tripe" Deming house on the west end of Flagstaff village is shown here. Deming (seated on porch) is talking with a representative from CMP. (Courtesy of DRAHS.)

The Arthur and Beatrice "Trix" Rogers house was on the west side of town. This house was moved to Eustis and is now a private residence located near the Cathedral Pines. (Courtesy of DEW.)

Another view of the western end of Main Street of Flagstaff village looks from the Almon Deming house down to the congregational church on the other end of the village. (Courtesy of DRAHS.)

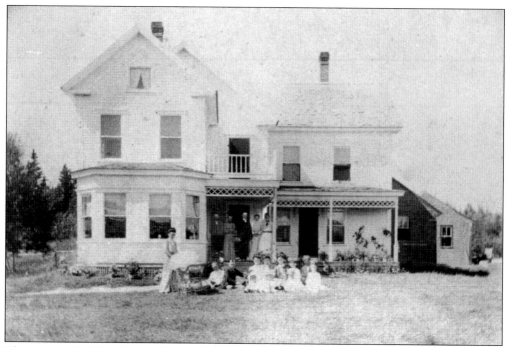

This is the John Viles farm in Flagstaff, up near Shep's Logan on the western end of the village. John's first wife was Olena F. Viles, and they had 11 children. His second wife was Etta Hammond Viles, and they had 8 children. (Courtesy of DEW.)

The Cliff "Shep" Butler farm buildings were located across the dead end road from the home of Carl and Mae Savage. (Courtesy of DRAHS.)

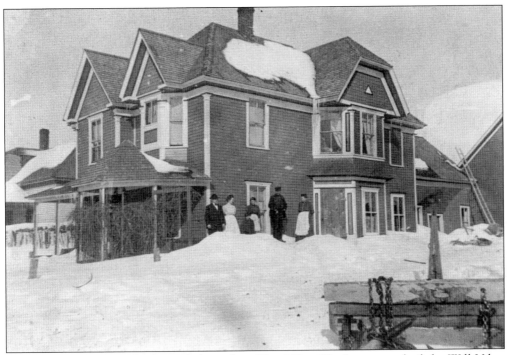

Pictured around 1905, this home belonged to Glen Viles. The house was built by Will Viles, Glen's uncle. (Courtesy of DEW.)

This store, originally built for Myles Standish, was the George Lincoln Store from 1901 to 1905. Al Wing bought it in 1906 and ran it until 1911; then C. C. Lincoln ran it from 1923 to 1928. A. P. Wing then leased it to his son-in-law Hazen Ames, who ran it as a pool hall and a barbershop. He and his wife, Hilda Wing Ames, lived upstairs. (Courtesy of June Leavitt Parsons.)

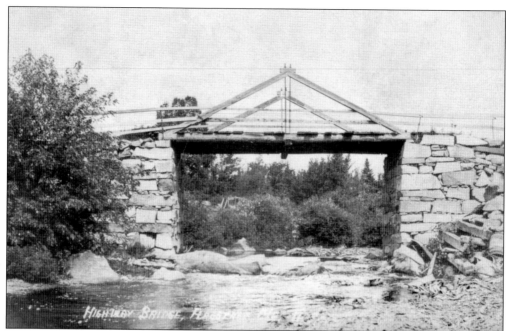

This is an early view of the Mill Stream Bridge in Flagstaff village. Piles of logs and heavy barrels were placed on top of this bridge during floods to keep it from floating off. (Courtesy of Earl Jr. and Wendy Wyman.)

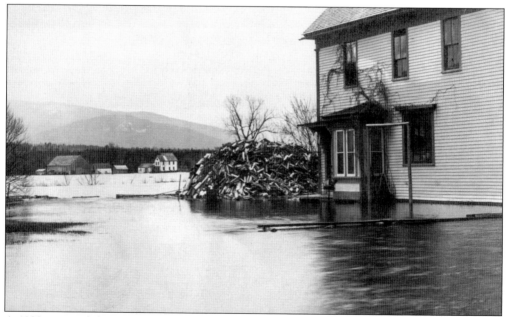

A 1923 postcard shows springtime floodwaters, with the Butler and Savage general store in the foreground. Note the John Ricker farm in the background, located south of the Dead River in Bigelow Plantation. (Courtesy of DRAHS.)

This is the view looking up the dead end road between Mae Savage and Cliff Butler's. The two cabins at the end were originally from Camp Elliot Bacon in Dead River and were owned by Al Wing. The left-most camp was bought by Evan Leavitt in 1949 and moved to Eustis next to his new store. It was later moved to a development near Eustis village. The house on the left was known as the Chatfield House. (Courtesy of June Leavitt Parsons.)

The Abial and Saba Heath Stevens farmhouse is shown around 1900. This farm was situated close to the Eustis town line on the north side of the Dead River. Marshall Myers and his wife, Lena Brackett Myers, bought it in 1918 and raised sheep. Saba Stevens was Lena's grandmother. (Courtesy of Caleb Stevens.)

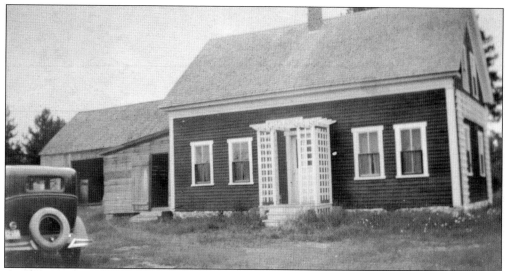

This was a red-colored house across the road from the Smith farm. Marshall "Marshie" Myers bought it soon after he obtained the Smith farm, and he let hunters and other sportsmen use it. Someone hung up the sign proclaiming it to be "Myers Lodge," and the name stuck. Alonzo Knowlen bought this house in 1949 and moved it to a new location between Stratton and the Cathedral Pines, where he lived in it for many years. (Courtesy of DRAHS.)

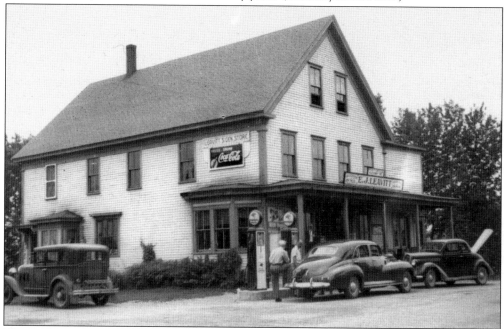

The Butler and Savage general store was built in 1888 by David Butler for his son-in-law Carl Savage. Known as the Butler and Savage general store until 1924, it was later run by Harold Flint as the H. B. Flint general store until 1941. It was last operated by Evan "Dutchie" Leavitt and his wife, Evelyn, until the lake was formed in the spring of 1950. Carl Savage passed away in 1942, and his wife, Mae, did not settle with CMP until after 1950. This is why this building, her house, and other properties were left standing during the first year of the lake. (Courtesy of June Leavitt Parsons.)

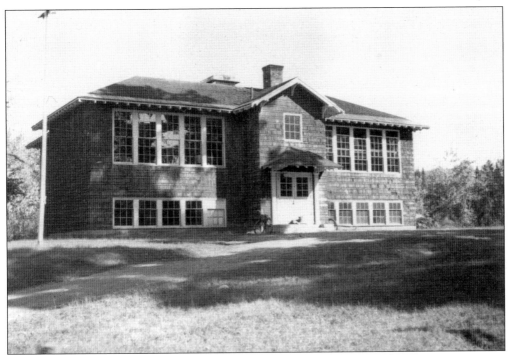

The new Flagstaff school was constructed in 1931. (Courtesy of DRAHS.)

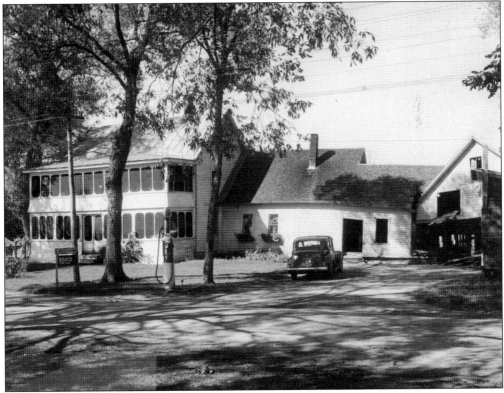

This is a *c.* 1945 view of the Wing House. (Courtesy of DRAHS.)

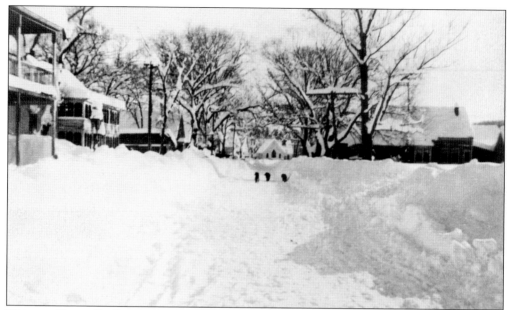

This is a Flagstaff village snow scene in November 1943, just a few days before Thanksgiving. It snowed for two consecutive days and deposited 45 inches of snow. The three dogs were Cliff Wing's English water spaniels, which he bred and sold. (Courtesy of DEW.)

The Mae Savage house, with its beautiful glassed-in porch, is shown here in the late 1940s. (Courtesy of DRAHS.)

The Lester Burbank house is shown here on Main Street in Flagstaff. (Courtesy of DRAHS.)

This is one of the two Camp Elliot Bacon camps from Dead River owned by Al Wing and moved up to Flagstaff village. This particular camp was used exclusively by John and Doris Tibbetts during the summer months. (Courtesy of June Leavitt Parsons.)

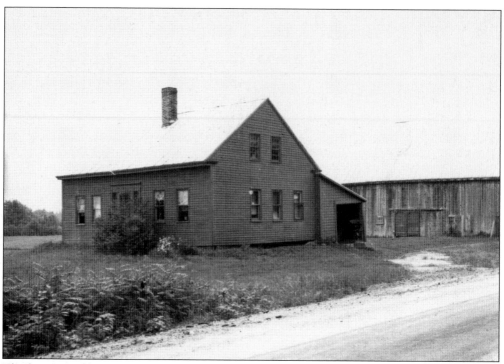

The farm owned by Walter Hinds, not to be confused with his house in Flagstaff village, was built by the younger Will Gammon. His daughter, Helen, married Walter Hinds. (Courtesy of DEW.)

This is the Ellery and Hazel Viles Savage cottage, which was situated across from the home of Ellery's mother and father, Carl and Mae Savage. (Courtesy of DRAHS.)

The Etta Viles cottage on Main Street was located across from Ken Taylor's home. (Courtesy of DRAHS.)

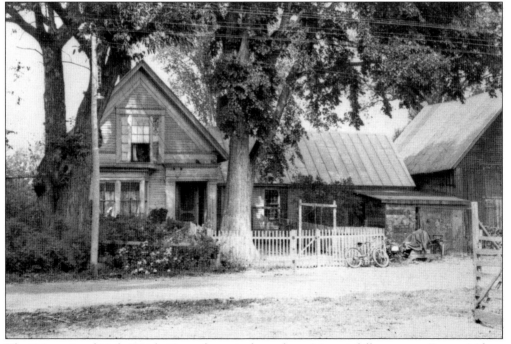

The "Monty" and Viola Wright Young home is shown here. Monty's full name was Everett Milton Young, and he originally came from the Bangor area. Viola's parents were Arthur and Ena Wright, and Viola grew up in this house. (Courtesy of June Leavitt Parsons.)

This house, owned by Myron Stevens, was the last on Pond Road. It is shown in the winter of 1949–1950. Previous occupants of the home were Howard and "Peggy" Rogers, Cleo and Georgia Ashley, Harold "Bat" Simpson, and Vertna and Minnie Cox. (Courtesy of June Leavitt Parsons.)

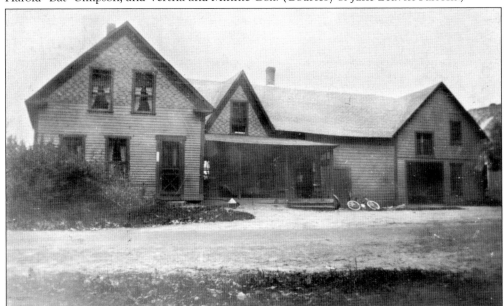

The Frank and Annie Wahl Ashley house was on Main Street in Flagstaff. They also took in boarders. (Courtesy of DEW.)

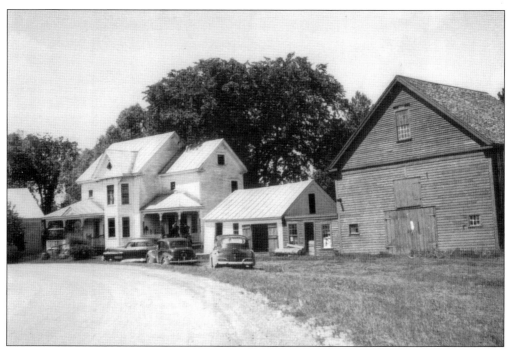

This house, owned by Walter and Helen Gammon Hinds, is shown in 1949. It was located at the eastern end of Main Street right where the road took a sharp turn near the church. (Courtesy of DEW.)

Here is a view of Flagstaff Pond at the Great Northern Paper Company (GNP) storehouse, which was at the end of Pond Road. The storehouse was built by Ken Taylor and Percy Parsons in 1945 while they were working for GNP. It was also known as Cliff Wing's boat landing. Pictured here is his "ferry boat," with which he transported livestock and supplies across the pond while pushing it with his motorboat. (Courtesy of June Leavitt Parsons.)

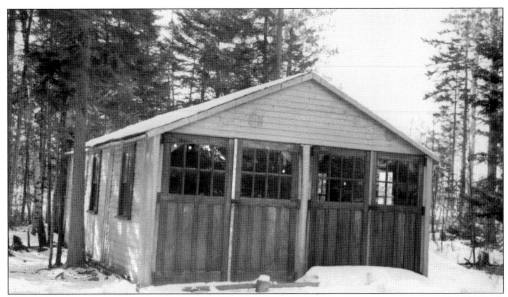

Otto Lindburg's Shaw Pond Garage was near the end of Pond Road up near Flagstaff Pond. Lindburg, who also owned Shaw Pond Camps, was a descendant of Charles Lindbergh. (Courtesy of June Leavitt Parsons.)

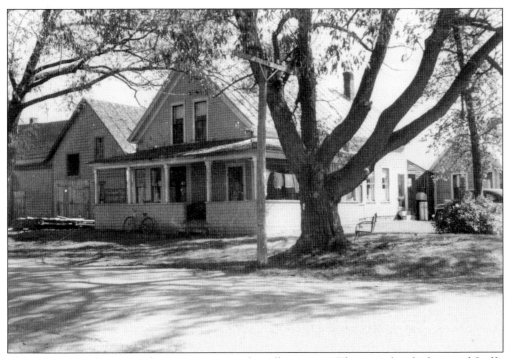

The Goff and Arlene Wing house was next to the village green. This was also the home of Goff's parents, Ralph and Maude Wing. Ralph was a master driver for Kennebec Log Driving Company, also called the KLD. (Courtesy of DRAHS.)

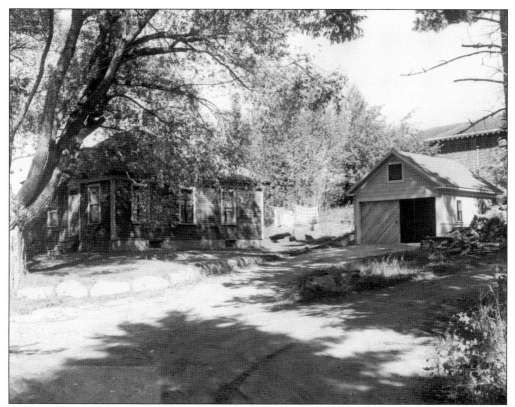

This was the Percy and Julia Blackwell Parsons house, just downhill from the Flagstaff school. Pictured here is also the garage owned by Forrest Parsons, which was moved to Eustis and is now incorporated into a residence located between Cathedral Pines and Stratton village. (Courtesy of DRAHS.)

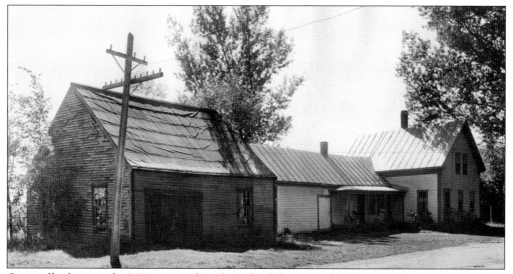

Originally this was the J. Eugene and Ruth Burbank house and blacksmith shop on Main Street. "Gene" worked in his shop full time and invented and patented a bucksaw tightener. This place was later owned by their son Perry and his wife, Charlotte Burbank. (Courtesy of DRAHS.)

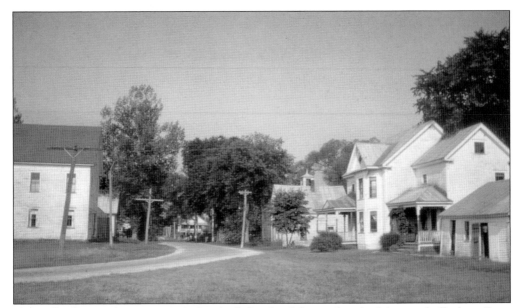

Flagstaff village is shown in 1948. On the left side of the road is the Masonic hall, then Gene Burbank's blacksmith shop, and Perry Burbank's house. On the right side of the road is the home of Walter Hinds and then Lester Burbank's house. The pool hall run by Hazen Ames is at the far end. (Courtesy of DEW.)

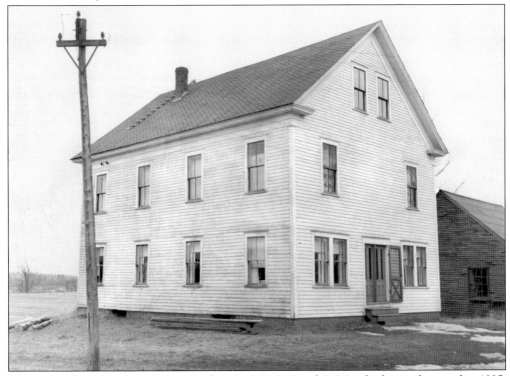

This is the Mount Bigelow Masonic Lodge No. 202, A. F and A. M., which was chartered in 1895. CMP would later build a new Masonic lodge for the Masons in Stratton across the road from the Stratton school. (Courtesy of DRAHS.)

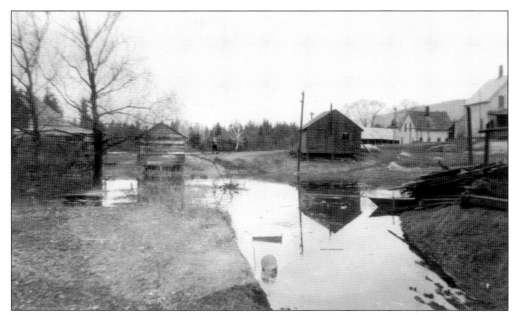

This is Mill Hollow, with the H. G. Bryant Mill on the left, the Harry Bryant house on the right (previously owned by Warren Wing, a famous bear trapper and bear hunter), and the Roy Jackson home in the background (formerly the Arthur Rogers house). (Courtesy of June Leavitt Parsons.)

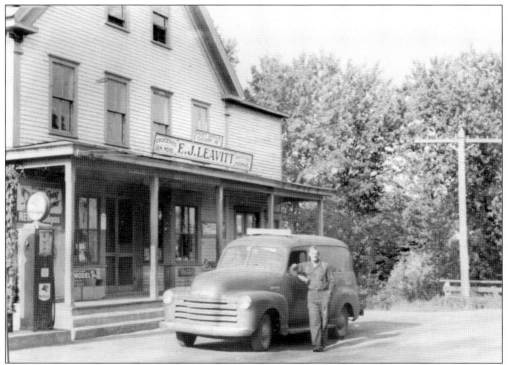

Monty Young and his stage are in front of the E. J. Leavitt general store in the late 1940s. He ran this stage daily to North Anson carrying mail and passengers to and from Flagstaff. (Courtesy of DEW.)

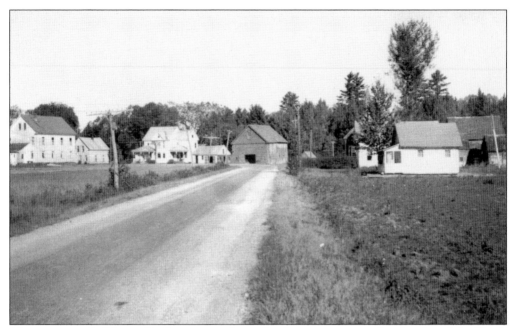

The eastern end of Flagstaff village proper shows the sharp corner near the church and the Hinds house in 1948. The Masonic lodge is shown at the far left, and the Duluth and Betty Wing house is on the far near right. (Courtesy of June Leavitt Parsons.)

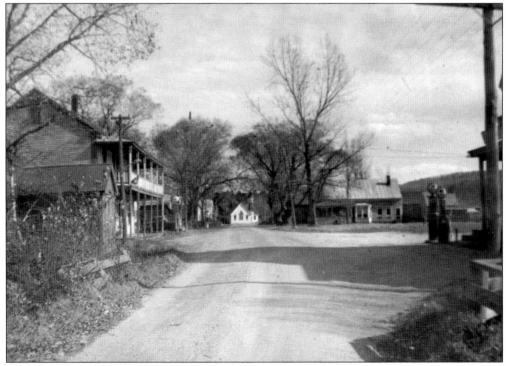

Flagstaff village is photographed from the Mill Stream Bridge. Shown here is the village green on the right just before the Goff Wing house. The Hazen Ames pool hall is on the left with the little town fire house on this side of the pool hall. (Courtesy of DRAHS.)

"Carl's Flats" and stacks of squares from the H. G. Bryant Mill are shown here. These white birch squares were stacked there to dry and were later sent to Locke Mills to be turned into dowels. Just to the left of these squares is the Marshall Douglas house, then to the left of that is the Kirk Targett house. The farm on the left was the Benjamin "Deke" Savage farm, which was later owned by his son Carl Savage, hence the later nickname "Carl's Flats." The remains of the CCC camp can be seen to the left of the big barn. (Courtesy of DEW.)

This 1949 photograph is of the Duluth E. and Betty A. Wing house. Originally this was a camp built in Langtown by Duluth's half-brother, Lem Denis Moody. Later in the fall of that year it was moved to a location near the Cathedral Pines and used by the Wings as their new residence. (Courtesy of June Leavitt Parsons.)

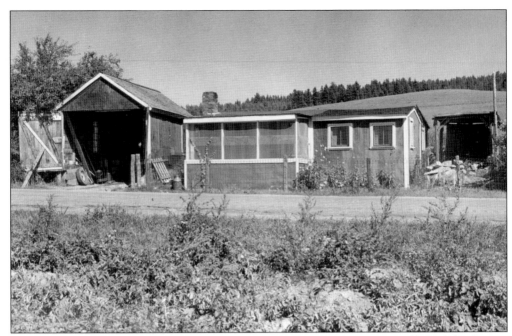

The Arthur Frank Rogers place is shown around 1946 or 1947. It was originally built by George Cole in the early 1940s, a period of time when he carried mail from Flagstaff to New Portland. The house was located between the Perley Stevens farm and the town cemetery. (Courtesy of DRAHS.)

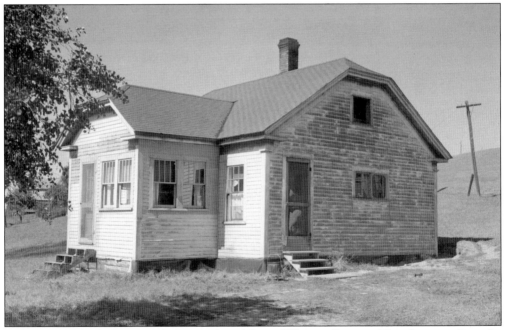

Perley Stevens built this place for his mother, Alberta Whittier Stevens. Then his sister Dorothy Stevens lived here with her husband, Clarence Jones. In 1949, this house was moved to Eustis near the present Flagstaff Cemetery, and it was used by Perley Stevens as his new home. (Courtesy of DRAHS.)

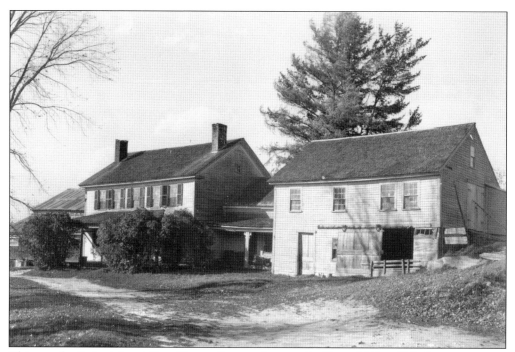

This was the Perley M. and Cora Norton Stevens farm on Jim Eaton Hill in 1949. Previous owners were Perley's father, Myron Stevens; Ray Viles; and Tappen James Eaton (going back to at least 1883). This house was never flooded out, being above the shoreline of the new lake, and was later burned by CMP. (Courtesy of DRAHS.)

This is a postcard photograph looking up the Dead River from the covered bridge. Through the trees on the left side the old John Ricker farm can be seen, and in the far background is the Alvin "Al" Wing farm. (Courtesy of DEW.)

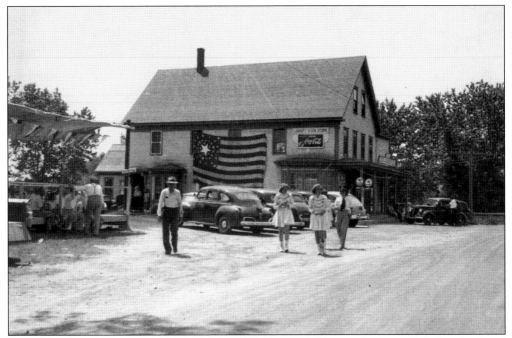

The last Fourth of July celebration in Flagstaff took place in 1949. The large U.S. flag displayed on the side of the general store was handmade by ladies in the area. It is still in existence and is the property of the Flagstaff Chapel Association.

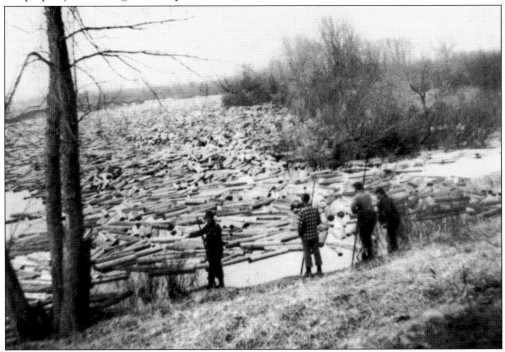

A late-1940s photograph shows river drivers watching their pulp coming down the Dead River behind the E. J. Leavitt general store. From left to right are Bill Wahl, Warren Milliken, Erwin Targett Jr., and Robert Targett. (Courtesy of DRAHS.)

Four

PEOPLE OF THE VALLEY

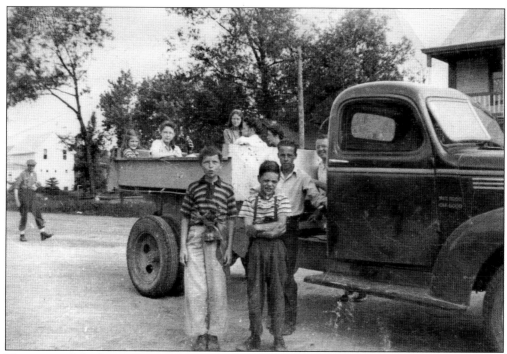

The story of the lost villages of Flagstaff Lake is a human-interest story. The unfathomable disruption in the lives of former residents, of having to leave their lifelong homes and start anew is compelling. Perley Stevens furnished this truck to take Flagstaff kids up to the movies in Stratton, and it became known as the "Kid's Taxi." Pictured from left to right are Harry Bryant, Marion Jackson, Isabelle Burbank, Loen Burbank, Polly Jackson, Beulah Ames, Stanley Jackson, Geraldene Ames, Duluth Wing, and Ken Taylor. (Courtesy of DRAHS.)

Walter Hinds is pictured
here around 1940.
(Courtesy of DEW.)

Shown below are Ruth
and J. Eugene Burbank.
(Courtesy of DEW.)

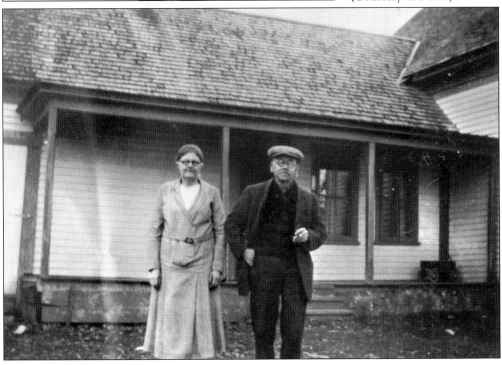

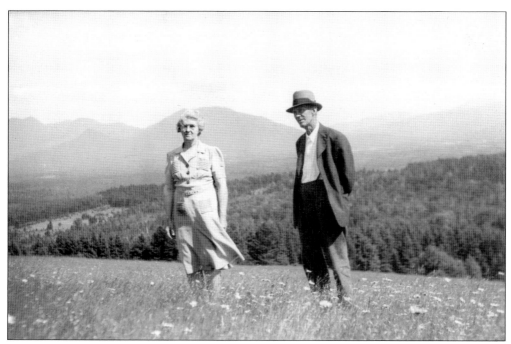

Alice and Harry G. Bryant are pictured here in 1945. (Courtesy of Lydia Bryant.)

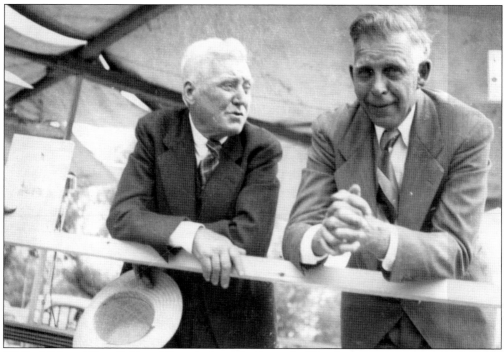

Clifford Edwin Wing (left) and Rev. Arthur MacDougall of Bingham are pictured during the last Fourth of July celebration in Flagstaff in 1949. (Courtesy of Fred Hutchins.)

Eva Parsons Wing and Alvin P. Wing are pictured here. (Courtesy of June Leavitt Parsons.)

Al Wing rides his horse, named Budweiser, in front of the Hazen Ames pool hall and town firehouse. This building was moved to Eustis and is located near the Flagstaff Cemetery. (Courtesy of DEW.)

This was the mail stage during the late 1800s, which ran daily from Flagstaff to the Carrabassett railroad station. It is pictured here in front of the Flagstaff Hotel, and its driver is either Leon Wing or Charles Norton. (Courtesy of DEW.)

Sibyl Myers is with her mother, Lena Brackett Myers, and father, Marshall "Marshie" Myers. Lena was a well-known midwife throughout the area, and it is claimed she helped some 600 mothers bear their children. (Courtesy of Anna and Bill Smart.)

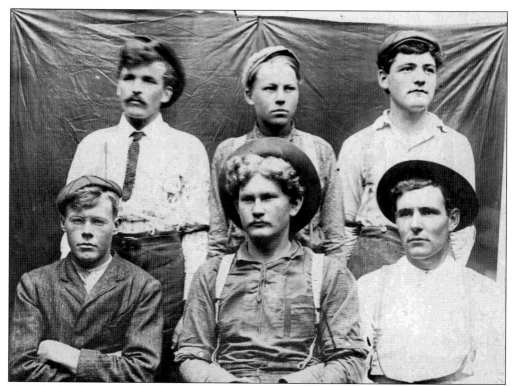

This is a 1905 photograph of six men from Flagstaff. Pictured from left to right are (first row) Alphonse Dion, Alton E. Burbank, and Arthur W. Rogers; (second row) Lester E. Burbank, Harry J. Lincoln, and Herbert S. Rogers. (Courtesy of DEW.)

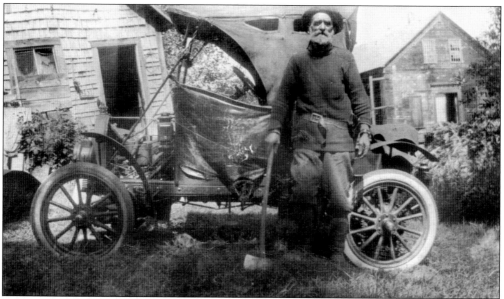

Herbert "Bert" Russell Horton poses in front of his house and his 1912 Brush Runabout. (Courtesy of DRAHS.)

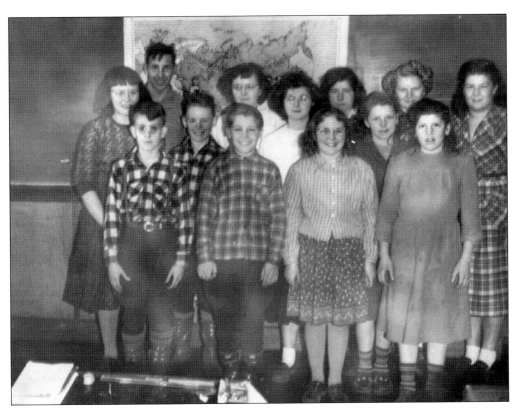

Here is Flagstaff's 1948 seventh- and eighth-grade class. Pictured from left to right are Shirley Morris, Elton Burbank, Blyn Cox, unidentified, David Targett, Janet Safford, Elsie Safford, Marilyn Morris, Rosalie Targett, either Violet or Valetta Pinkham, June Leavitt, either Violet or Valetta Pinkham, and Louise Storey. (Courtesy of June Leavitt Parsons.)

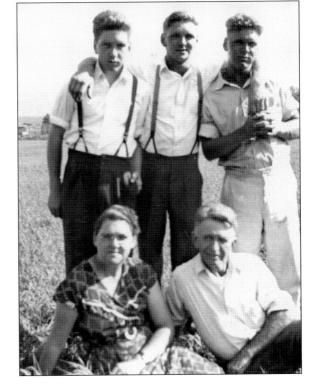

Pictured at right are members of the Ashley family. Seated are Annie Wahl Ashley and her husband, Frank; standing left to right are Harold "Guy," Cleo "Pete," and Waldron. (Courtesy of DEW.)

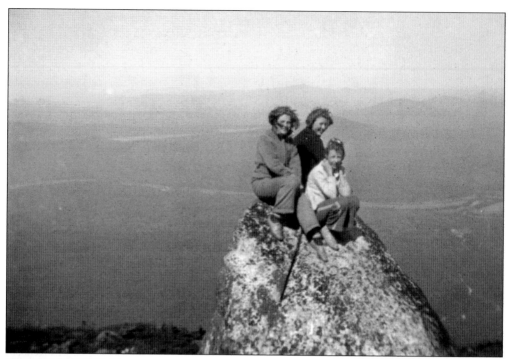

From left to right, Sally Rogers, Eleanor Flint, and Margaret "Peggy" Wing are posing on top of Mount Bigelow, with the Dead River Valley in the background. (Courtesy of DEW.)

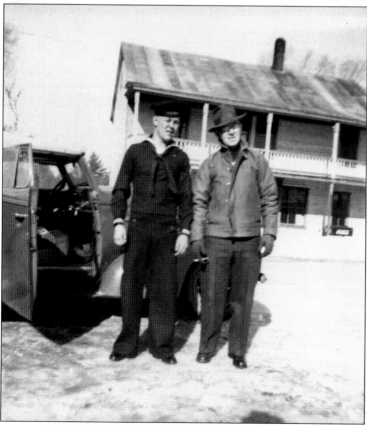

Carroll Leavitt (left) is pictured with his father, Evan "Dutchie" Leavitt. (Courtesy of June Leavitt Parsons.)

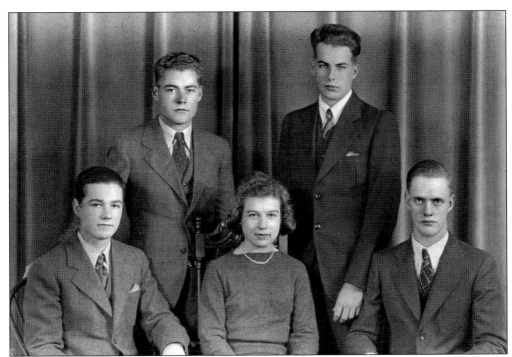

Flagstaff High School's class of 1939 is shown here. From left to right are (seated) Howard Rogers, Eleanor Parsons, and Curtis Bryant; (standing) Guy Rogers and Eugene Burbank. (Courtesy of DRAHS.)

Barbara Wing was a member of the class of 1945. (Courtesy of DRAHS.)

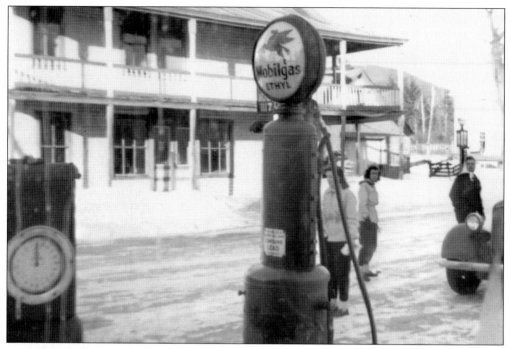

Pictured from left to right are Geraldine "Deenie" Ames, Ruey W. Stevens, and Freda Targett. They are standing between E. J. Leavitt's store and Hazen's pool hall in the background. (Courtesy of June Leavitt Parsons.)

Loen Burbank was a member of the class of 1948. (Courtesy of DRAHS.)

The total student body of the Dead River School is shown here in the spring of 1938. From left to right are (first row) Helen Donahue, Olive Donahue, June Baily, David Wing, and Edgar Baily; (second row) William Wing, Loretta Knowlan, George Wing, Gladys Bean, Christine Donahue, Maurice Wing, and Vernon Bean; (third row) Gladys Safford, Leon Wing, Florian Burbank, and Perley Durgin. (Courtesy of Vernon O. Bean.)

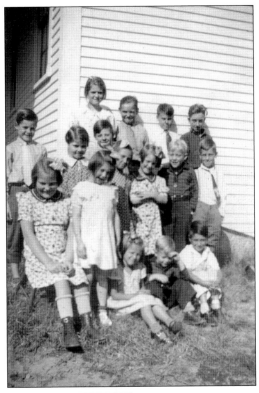

Duluth "Dude" and Betty A. Wing are shown in their house in 1949. (Courtesy of June Leavitt Parsons.)

Eleanor Parsons (left) and Lydia Bryant are pictured above. (Courtesy of DEW.)

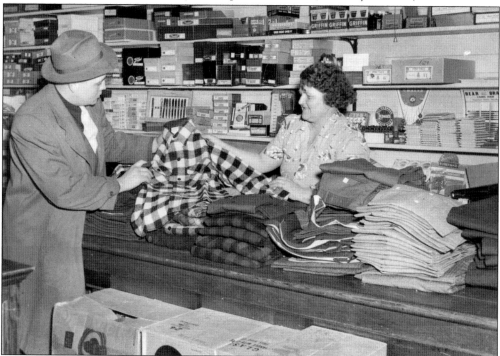

Evelyn Leavitt is photographed with a clothing salesman in the E. J. Leavitt general store in 1948. (Courtesy of DRAHS.)

Edwin R. "Ted" Targett (left) and Lawrence Wing are shown in the E. J. Leavitt general store. (Courtesy of DRAHS.)

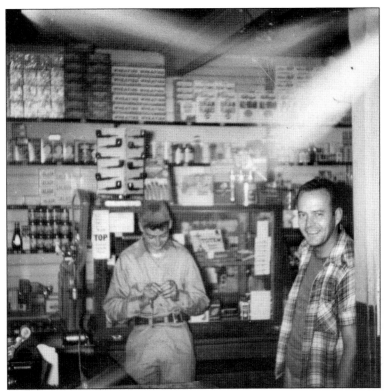

This is a photograph of Everett L. Parsons. (Courtesy of DRAHS.)

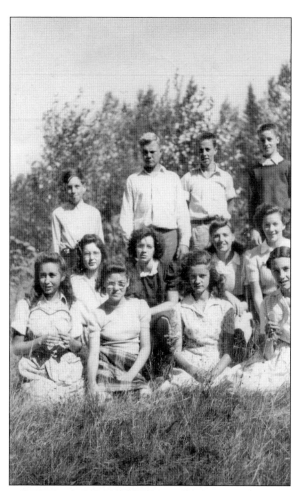

This photograph shows the Flagstaff High School's 1943–1944 student body. Pictured from left to right are (first row) Ruey Stevens, Polly Jackson, Marilyn Houston, and Joanne Yeaton; (second row), Isabella Burbank, Beulah Ames, Freda Targett, and Geraldine Ames; (third row) Vernon Bean, Carroll Leavitt, Duluth Wing, and Herbert Targett. (Courtesy of DRAHS.)

The 1938–1939 Flagstaff school girls' basketball team is pictured with their coach. From left to right are (first row) Eleanor Burbank, Ruth Stevens, Eleanor Parsons, and Margaret Wing; (second row) coach Ken Taylor, Glenys Safford, Eleanor Flint, Muriel Targett, and Sally Rogers. (Courtesy of DRAHS.)

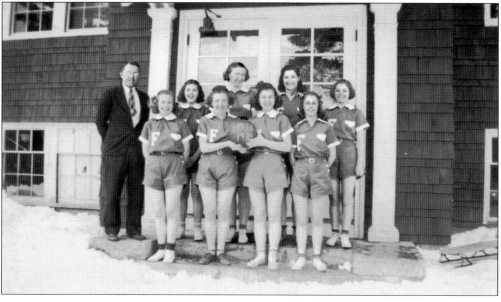

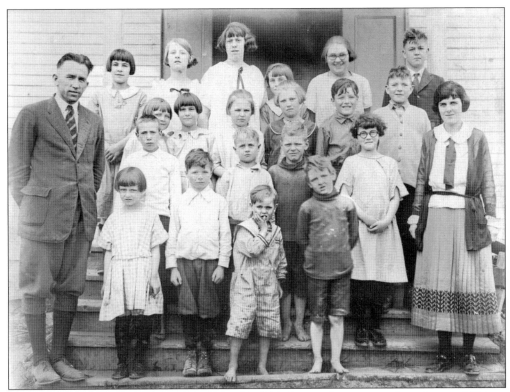

The Flagstaff student body is pictured on May 30, 1924. Among those pictured are (first row) Hubert Ryan, Glenys Wing, Robert Rogers, Theron Stevens, and Cleo Ashley; (second row) Lewis Collins, Virgil Norton, Waldron Ashley, and Olive Wing; (third row) Inez Crymble, Madeline Deming, Laura Crymble, Georgie Wing, and Herbert Rogers; (fourth row) Louise Deming, Dilana Moody, Viola Collins, Hilda Deming, unidentified, and Charlie Crymble. (Courtesy of DRAHS.)

Forrest and June Leavitt Parsons (on the left) are shown with Forrest's sister, Eleanor, and her husband, Glen White. (Courtesy of June and Forrest Parsons.)

Freda (left), Albion (center), and Robert Targett are pictured in the early 1930s. (Courtesy of DEW.)

This is a photograph of George Bryant. (Courtesy of DRAHS.)

This group photograph was taken on Warren and Flora Wing's porch. Pictured from left to right are (first row) Maurice Cox (?), Viles Wing, Harold Burbank, Ernest Chatfield, and Dewey Wing (second row) Faye Taylor, Dot Viles, Gayle Viles, Goff Wing, Gwendolyn Wing, and Florence Taylor. (Courtesy of DEW.)

Howard and Margaret Wing Rogers are pictured with their son, Jimmy Clifford Rogers. (Courtesy of DEW.)

Janice Young is with her father, "Monty" Young. (Courtesy of DEW.)

Posing around 1947 on the village green near the town flag staff are, from left to right, (first row) Dana Stevens and Mike Stevens; (second row) Joyce Bean and June Leavitt. (Courtesy of June Leavitt Parsons.)

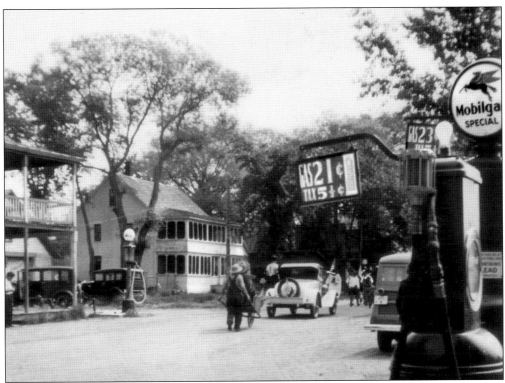

Pictured above is a Fourth of July parade in Flagstaff village. (Courtesy of DEW.)

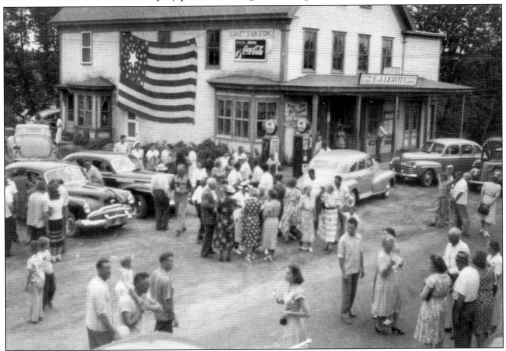

This photograph shows the last Flagstaff village celebration on July 4, 1949. (Photograph by Fred Hutchins, courtesy of DEW.)

Ken Morris (left), Vern Safford (right), and an unidentified man pose next to the firehouse and Hazen's pool hall. Safford, a CMP surveyor, drives a pickup truck issued by CMP. Note the CMP decal on the door. (Courtesy of DEW.)

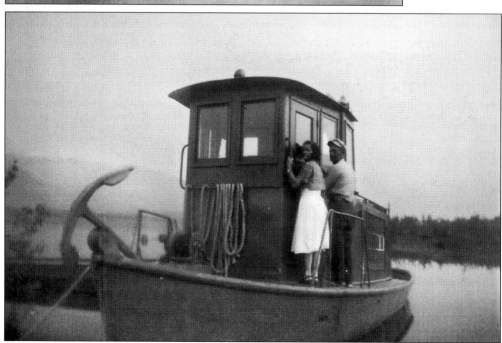

Mabel and Willie Kahkonen are on the *Middle Tow*. (Courtesy of DRAHS.)

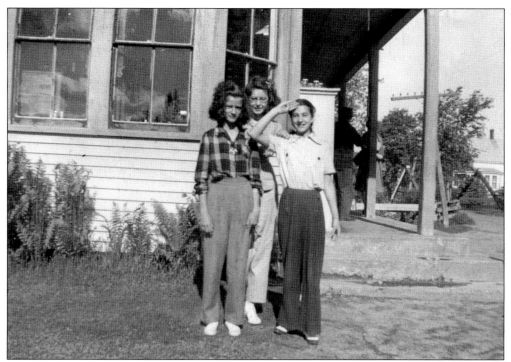

From left to right, Marilyn Houston, Isabelle Burbank, and Joanne Yeaton are preparing for their eighth-grade graduation trip to West Carry Pond, with Ken "Bill" Taylor as their chaperone. (Courtesy of DEW.)

Merton Crymble (left) and Percy Parsons are pictured here. (Courtesy of Forrest Parsons.)

Beulah and Olon Bean were photographed standing in 1943 with Dead River schoolteacher Zelma Meizner (left). The Beans's children, Gladys and Vernon, are kneeling in front. (Courtesy of Vernon Bean.)

This is a photograph of Richard Currier. (Courtesy of DRAHS.)

Robert Ames (left) and Herbert "Mitsey" Targett are pictured in 1943. (Courtesy of June Leavitt Parsons.)

Bus driver Leroy "Roy" Parsons is pictured in 1946 with the Dead River school bus. (Courtesy of DEW.)

This is a 1934 image at Spring Lake showing a day's catch of toque. (Courtesy of Earl Jr. and Wendy Wyman.)

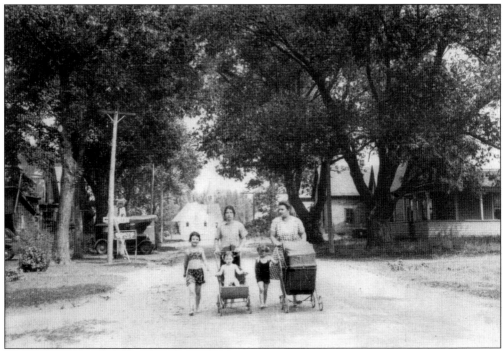

Strolling along Main Street Flagstaff are, from left to right, Olympia Targett, Margie Targett White pushing Barbara Lee Targett in a stroller, Carol Targett walking in the dark suit, and Anne Targett pushing the baby carriage. (Courtesy of Earl Jr. and Wendy Wyman.)

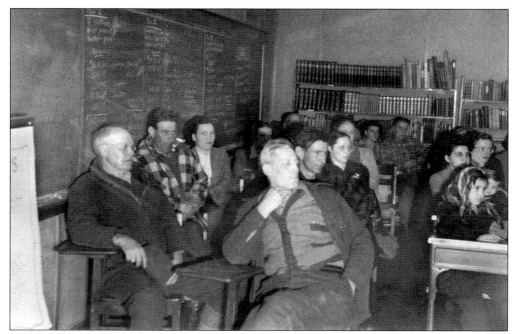

At the last Flagstaff town meeting in March 1949 are, from left to right, unidentified, Olon Bean, Beulah Bean, unidentified, Monty Young, Carroll Viles, Olof Bean, Charlotte Burbank, unidentified, Betty Wing, Duluth Wing, Vonetta Bean with children Joyce and Colby, and Lydia Bryant. (Courtesy of DRAHS.)

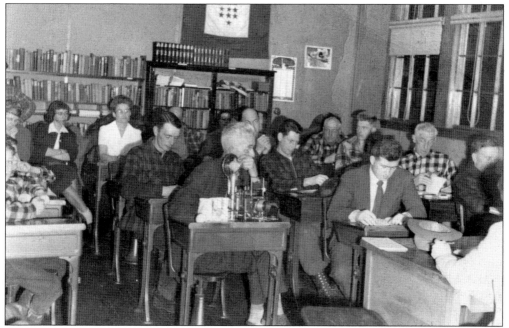

Also at the March 1949 final Flagstaff town meeting are, from left to right, David Targett, two unidentified, Duluth Wing, Ruey Stevens, Dot Stevens Jones, Harry Douglass, Percy Parsons, three unidentified, Evan Leavitt, Clarence Jones, Almon Deming, unidentified, Elwood Allen, Harold Flint, Perley Stevens, and moderator Kenneth Taylor. (Courtesy of DRAHS.)

Lubert Wing is pictured here. (Courtesy of DEW.)

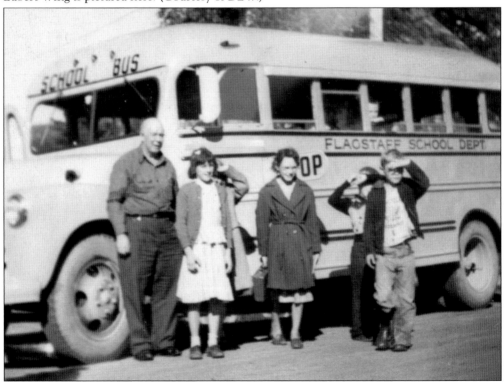

Percy Parsons (far left) is pictured in 1948 with a new school bus and some schoolchildren headed for Stratton. In the fall of 1948, all area students were bused to Stratton for school because the Flagstaff school was closed in preparation for the new lake. (Courtesy of DEW.)

Barbara Swan was a popular Flagstaff schoolteacher. (Courtesy of DEW.)

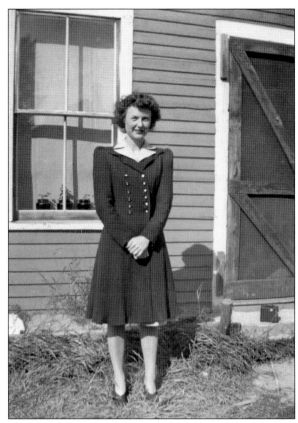

Mount Bigelow hikers from Flagstaff gathered on the steps of the E. J. Leavitt general store sometime during World War II. From left to right are Eleanor Flint Currier, Frances Savage Taylor, Eleanor Parsons White, Ruth Stevens Burquist, and Lydia Bryant. Duluth Wing, Carroll Leavitt, and Mike Targett retrieved all the pictured rubber tires from Mill Stream, and Dutchie Leavitt gave 1¢ per pound for them for the war effort. (Courtesy of DEW.)

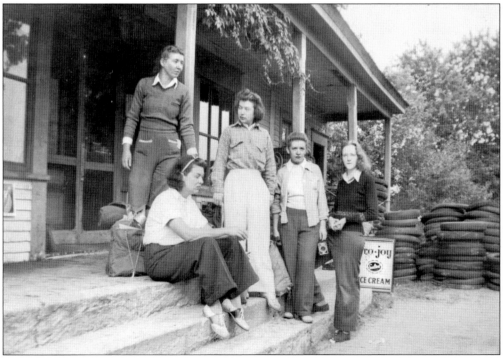

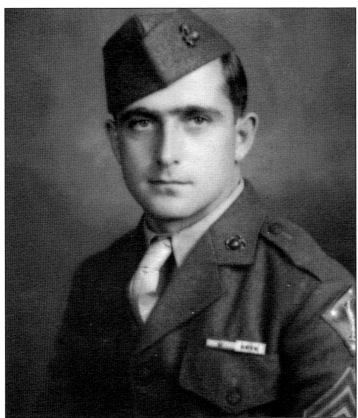

This is a photograph of Reginald "Renny" C. Stevens. (Courtesy of DRAHS.)

Pictured below from left to right are teacher Barbara Swan, Mildred Targett, Ruth Stevens, and Eleanor Flint. (Courtesy of DEW.)

Five

PREPARING TO LEAVE

Flowage cutting and clearing began in 1948, and the burning of the debris caused huge fires in the summer of 1949, as the companies were anxious to finish the project despite the dry conditions. Many people repurchased their buildings and moved them to neighboring towns, and the cemeteries were relocated. This photograph shows the war memorial honor roll monument being dug up for relocation to its new site in front of the Flagstaff Memorial Chapel in Eustis. (Courtesy of June Leavitt Parsons.)

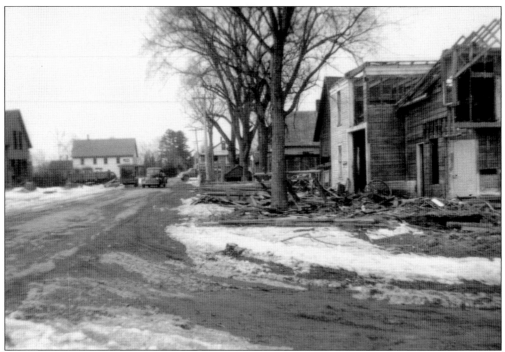

This photograph shows the demolition of the Lester Burbank house on Main Street in Flagstaff. Leavitt's general store is in the background. (Courtesy of DRAHS.)

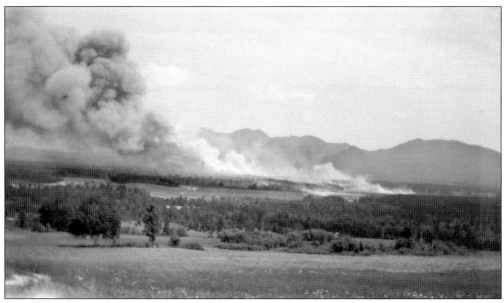

Clearing the area to be flooded, also known as clearing the flowage, began in 1948 and continued into early 1950. This photograph was taken on July 9, 1949, from Eustis Ridge and shows smoke from a large forest fire, which was caused by contractors burning brush subsequent to cutting trees and clearing the flowage. This fire burned an area that later became known as "the blueberry plains" due to the proliferation of blueberries. (Courtesy of DEW.)

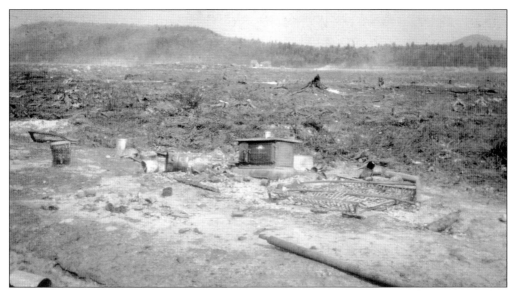

The summer of 1949 was very dry, and several houses were nearly burned by forest fires prior to the residents being relocated. This photograph shows a burned flowage area and a temporary flowage cutter's camp in Dead River Plantation, with Jim Eaton Hill and one of the Glen Viles farms in the background. (Courtesy of DEW.)

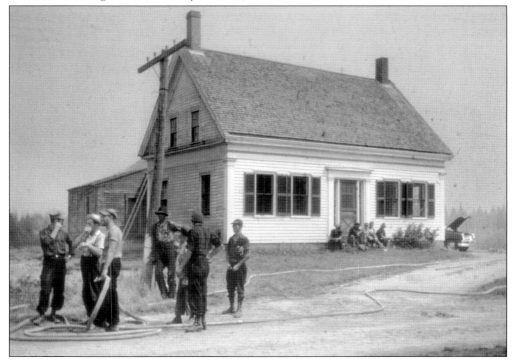

This photograph shows the Leroy Parsons house in 1949 with several firefighters gathered around to protect the house from an encroaching forest fire. Duluth Wing, the fire warden at the time, is shown standing to the immediate right of the man leaning on the telephone pole. Willie Kahkonen is to the right of Duluth, with his pants tucked into his boots and his gloves under his arm. (Courtesy of DRAHS.)

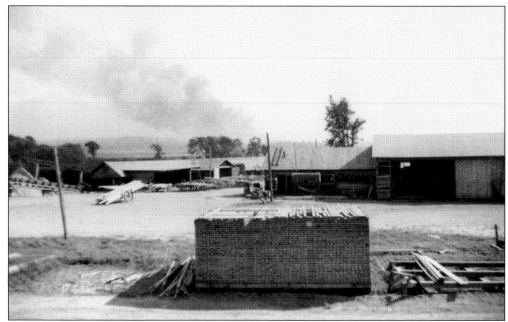

Viles Timberland Mill was running full-time during the flowage clearing, processing white pine from the flowage. All the lumber sawn here was eventually trucked to Stratton, where it was dried and sold. Also shown in this photograph is a forest fire burning in Bigelow Plantation. (Courtesy of June Leavitt Parsons.)

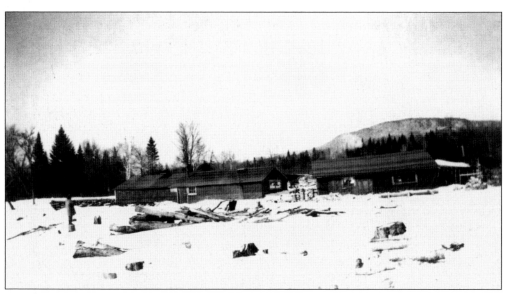

Woods crews moved in and stayed on-site, either in buildings abandoned by residents that were then owned by Central Maine Power, or they built temporary camps like the ones pictured above. They were paid $100 per acre for clearing the trees and burning the brush in preparation for the lake. (Courtesy of DRAHS.)

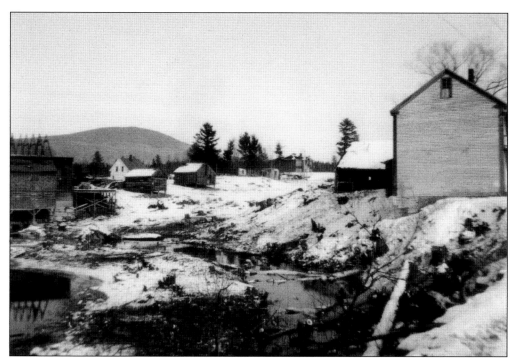

The H. G. Bryant Mill is shown during flowage cutting. The building on the right is the back of the Hazen Ames pool hall, formerly the C. C. Lincoln Store. (Courtesy of June Leavitt Parsons.)

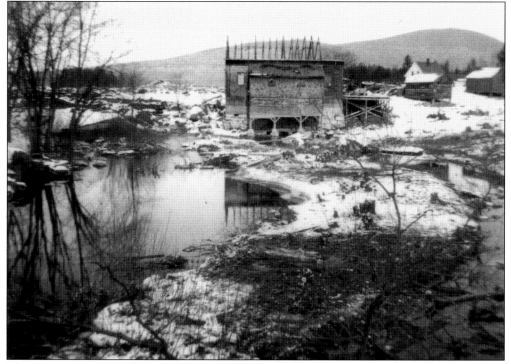

The H. G. Bryant Mill was demolished in the winter of 1948–1949. (Courtesy of June Leavitt Parsons.)

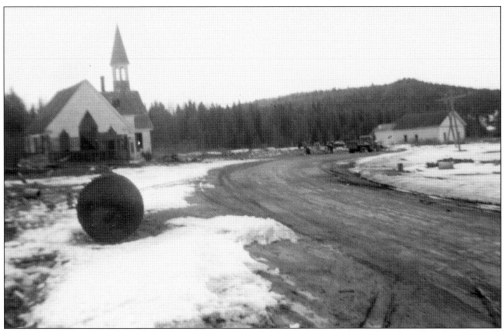

Central Maine Power Company built a new church in Eustis to replace this church. The stained-glass windows and bell were salvaged from this church and placed in the new Flagstaff Memorial Chapel in Eustis. The building on the right is the Hattie Rogers house, which was owned at this time by Alvin P. Wing. (Courtesy of June Leavitt Parsons.)

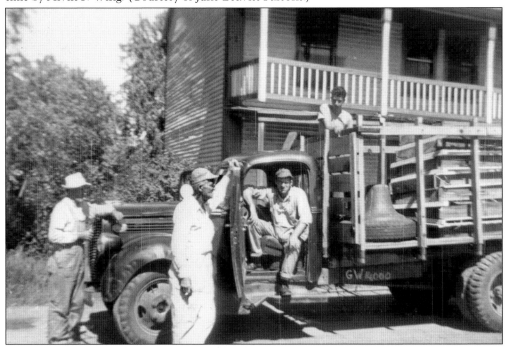

The church bell and windows are being transported to the new Flagstaff Memorial Chapel in Eustis. Identified in this photograph are Glen Viles (second from left), and his son Bruce, who is seated in the cab. (Courtesy of June Leavitt Parsons.)

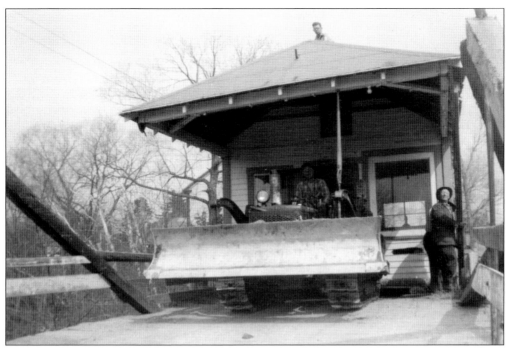

Workers are moving a building over the Mill Stream Bridge down Main Street in Flagstaff village. Robert Ames is on the roof, and Hazen Ames is standing at right. Note the sides had not been removed from the bridge at this time. (Courtesy of June Leavitt Parsons.)

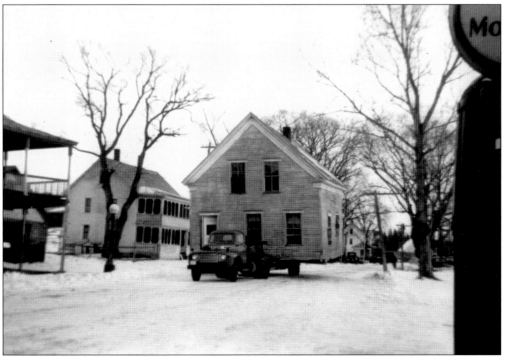

The Lester Burbank house is being moved. It was relocated to Eustis near the present-day airport and later razed. (Courtesy of June Leavitt Parsons.)

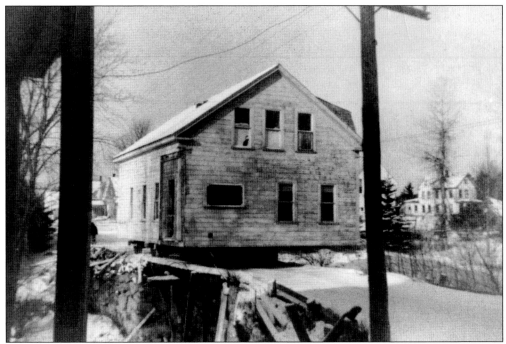

The Marshall Douglas house was relocated to Eustis between Stratton and the Cathedral Pines. Note that the Mill Stream Bridge has been modified in order to accept wider and heavier loads. (Courtesy of June Leavitt Parsons.)

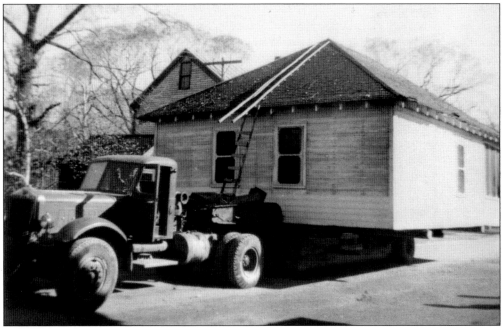

One of the Camp Elliot Bacon buildings Evan Leavitt purchased from the Morgan farm is being moved to a new location in Eustis, next to Leavitt's new general store near the Cathedral Pines (now known as Pine's Market). A man by the name of Nelson moved many of these buildings with his chain-driven Sterling tractor. (Courtesy of June Leavitt Parsons.)

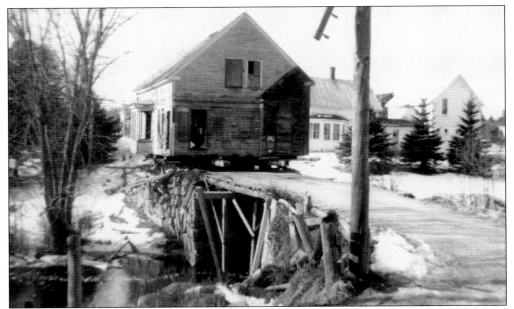

The Goff Wing house is being moved in 1949. It was relocated to Perry Road in Eustis. (Courtesy of June Leavitt Parsons.)

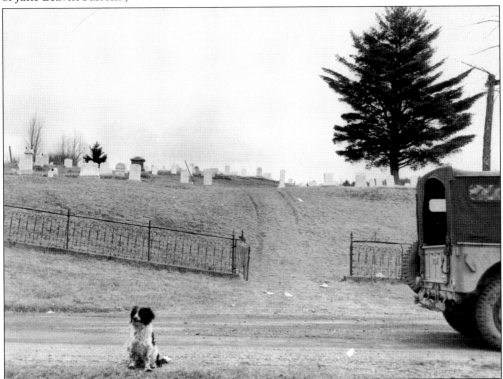

The Flagstaff Cemetery is shown here. The white pine tree was planted by Warren Wing when he was a young man, and his wish, which was carried out, was to be buried beneath it upon his death. This pine survived the creation of the lake and grew to be a large tree before being struck down by a bolt of lightning in the 1970s. (Courtesy of June Leavitt Parsons.)

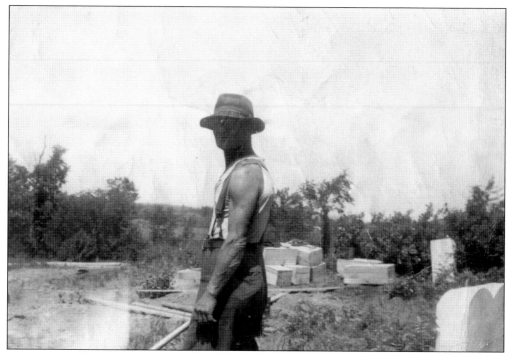

The graves in the cemeteries in Flagstaff and Dead River were moved to a new cemetery location in Eustis beside the newly constructed Flagstaff Memorial Chapel. This photograph shows Frank "Spider" Watson assisting with moving the remains. (Courtesy of DEW.)

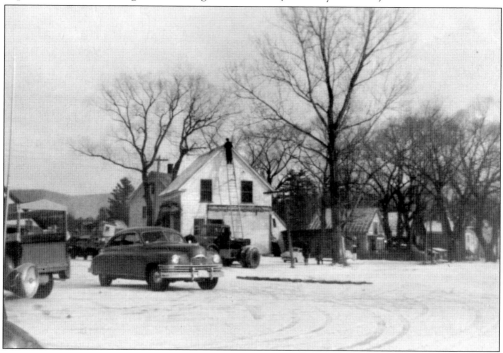

The preparation for moving the Harry Bryant house is being done using Nelson's chain-driven Sterling tractor. (Courtesy of June Leavitt Parsons.)

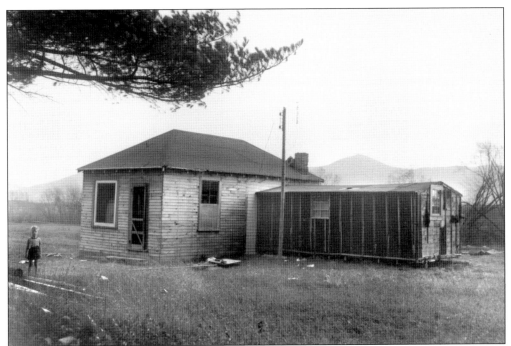

Some buildings were moved in and crude additions added in order to house the men cutting the flowage, and sometimes their families. This camp was located near Al's Pines. (Courtesy of June Leavitt Parsons.)

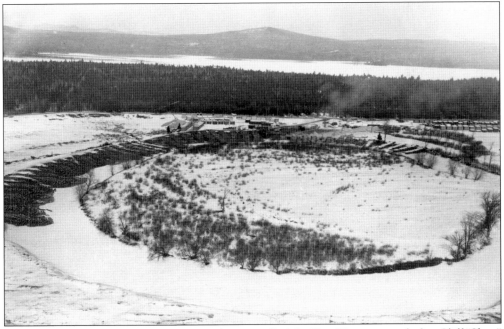

A 1949 aerial view of Shep's Logan, an oxbow cutoff of the Dead River named after Cliff "Shep" Butler, who owned all this land, shows Viles Timberland Mill, which was located west of Flagstaff village. Also shown here are piles of logs ready for sawing, with Flagstaff Pond and Burnt Hill in the background. (Courtesy of DRAHS.)

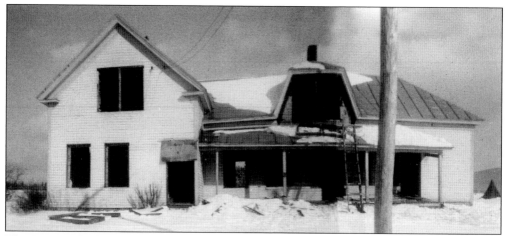

The Ken Taylor house in Flagstaff is being salvaged prior to flooding. (Courtesy of June Leavitt Parsons.)

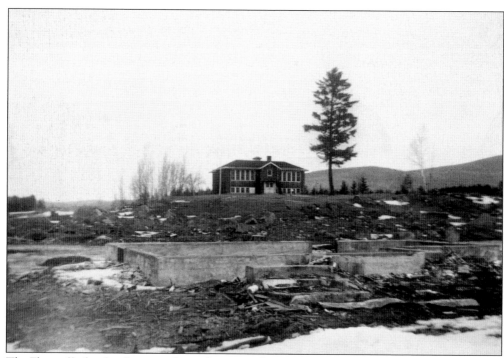

The Flagstaff school is shown in the early spring of 1950, with the foundation of the Walter Hinds house in the foreground. (Courtesy of June Leavitt Parsons.)

Six

THE VALLEY IS FLOODED

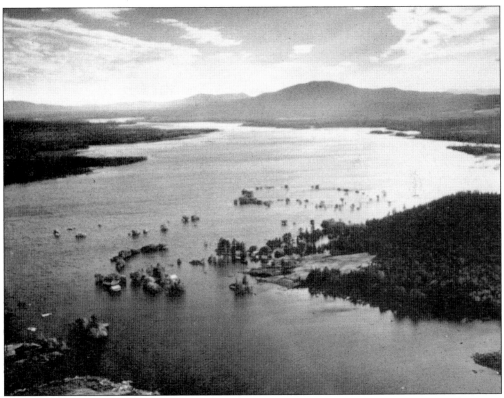

Flagstaff Lake is approximately 22,000 acres in size and is the fourth largest lake in the state. At full pond elevation, it holds more than 12 billion cubic feet of water and acts as a flood control facility and storage reservoir for several hydroelectric dams downriver on the Kennebec River; Wyman Dam in Bingham is the first. This postcard perpetuates the belief that there are still buildings sticking out of the lake, when in fact they were all burned by the winter of 1952. (Courtesy of DEW.)

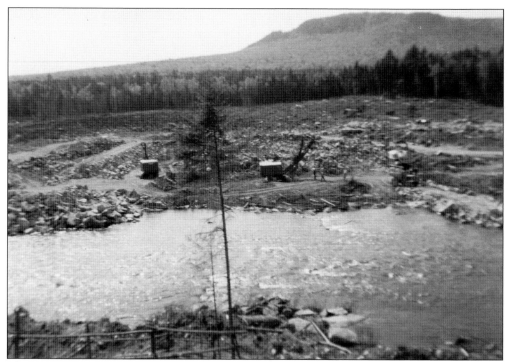

The construction of Long Falls Dam began in 1949. This photograph shows early excavation to bedrock to support the dam. A bypass for the river was cut through solid ledge at times 20 feet thick. (Courtesy of Earl, Jr. and Wendy Wyman.)

The Long Falls Dam is just under a quarter mile long, 360 feet wide at the base, 25 feet wide at the top, and slightly more than 50 feet high. (Courtesy of DEW.)

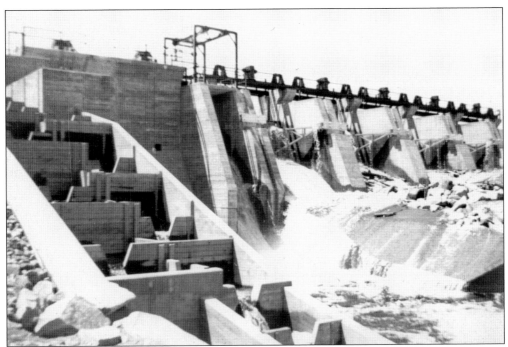

This photograph shows the five high and two low gates and the fishway structure in Long Falls Dam. (Courtesy of DEW.)

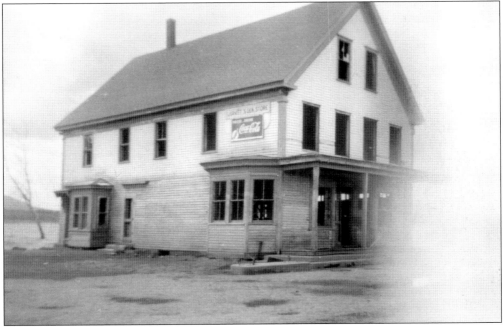

Leavitt's general store is pictured in Flagstaff in the fall of 1950. Note the waterline on the side of the building, indicating the water level during that year, the first year Flagstaff Lake existed. Each fall and winter, the lake level is lowered in order to capture spring melt and runoff, hence flood control for the Kennebec River and its dams. This is why each spring the water level in Flagstaff is so low, even to this day. (Courtesy of June Leavitt Parsons.)

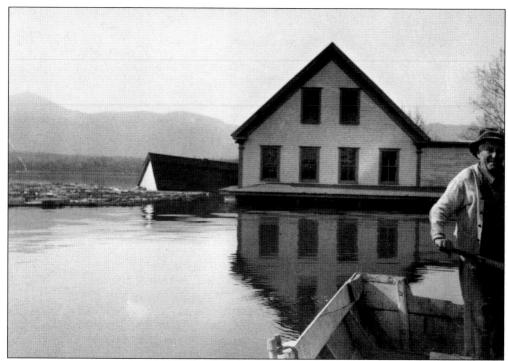

"Captain" Cliff Wing is in front of the E. J. Leavitt general store in 1951. The building behind the store was the attached shed, which had floated up off its foundation and turned sideways. Note the boom of the 4-foot pulpwood near the shed (a raft of pulpwood held together by a series of connected boom logs) in the background. (Courtesy of DRAHS.)

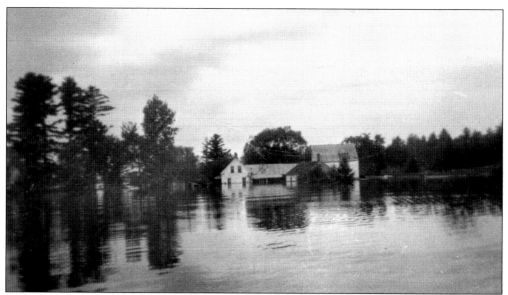

The Alvin Wing house and barns are shown in Flagstaff in 1950. (Courtesy of DRAHS.)

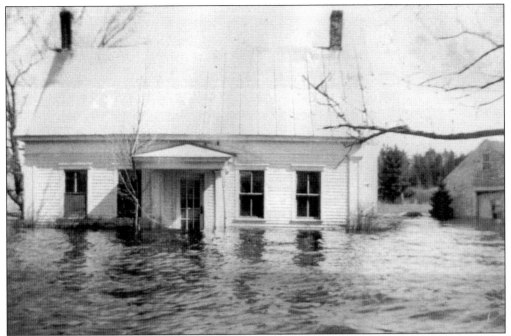

This is a close-up view of the Alvin Wing house in the spring of 1950, the first year Long Falls Dam was closed, creating Flagstaff Lake. (Courtesy of DRAHS.)

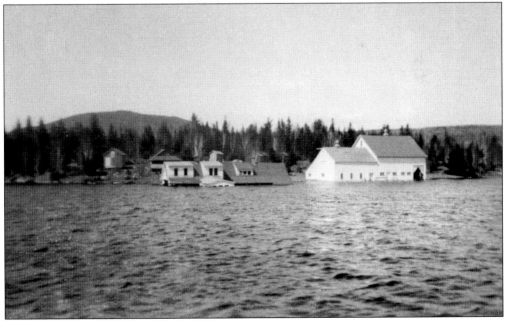

The J. P. Morgan farm at Dead River Plantation is shown here. The financier J. P. Morgan owned this and several other buildings. Two of the buildings were moved back to avoid flooding and were used as private summer cottages. (Courtesy of June Leavitt Parsons.)

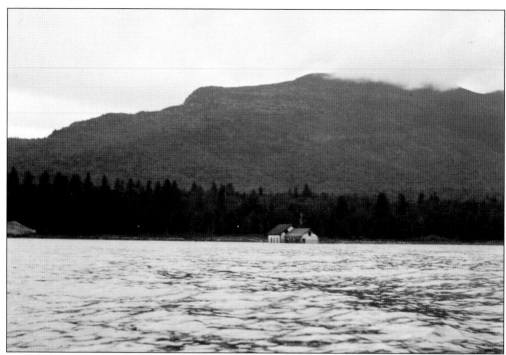

This is a 1950 photograph of the Hulseman house in Dead River Plantation. It was last occupied by the Frank Donahue family. (Courtesy of Earl Jr. and Wendy Wyman.)

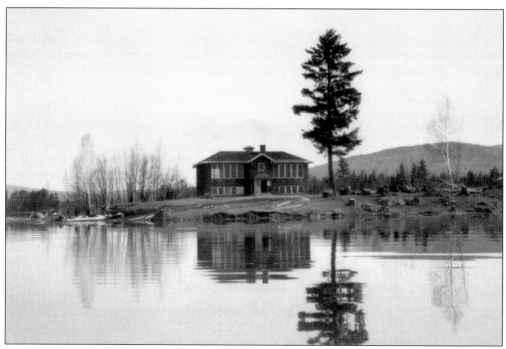

A salvage operation of the Flagstaff school is shown here. The boat was owned by Cliff Wing, who is shown assisting Roland Fotter of Stratton, who had the salvage rights for the school building. (Courtesy of DEW.)

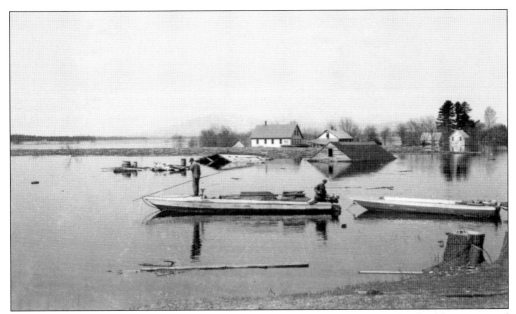

Boats belonging to Cliff Wing were used in salvaging the school building. Other buildings pictured include the Alvin Wing house, Leavitt's store building, the Hazen Ames pool hall, Cliff Wing's house (shown here on its side), and Hazen Ames's garage. Among all of this is a raft, sometimes called a boom, of 4-foot-long pulpwood, awaiting its turn to be hauled down the lake by the *Big Tow*. (Courtesy of DEW.)

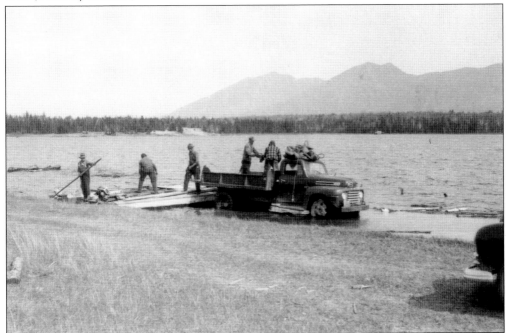

Cliff Wing (holding the pole), in the stern of his large boat, is assisting Roland Fotter, third from the left, with the salvage of the Flagstaff school. This photograph was taken at Myers Lodge Landing after Flagstaff Lake was created. Some of Charlie Savage's fields can be seen on the far shore. (Courtesy of DRAHS.)

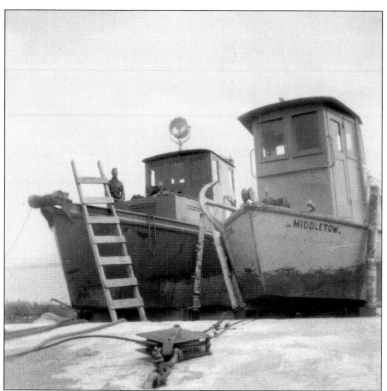

Central Maine Power had to take control of moving pulpwood down the newly constructed Flagstaff Lake to compensate for the loss of ability to use the river as transportation for the wood. Shown here are two boats, the *Big Tow* and the *Middle Tow*, which were used to move booms and rafts of pulp down the lake. (Courtesy of June Leavitt Parsons.)

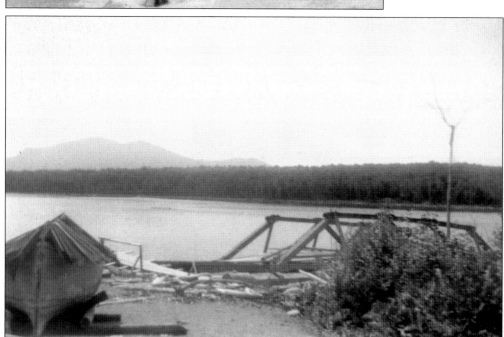

Central Maine Power Company used the big bridge, which originally replaced the covered bridge over Dead River at Flagstaff village, as a boat wharf near the Long Falls Dam. Also shown in this photograph is the *Little Tow*, which was used to move the wood within the rafts of wood and do other quick little jobs around the booms. (Courtesy of June Leavitt Parsons.)

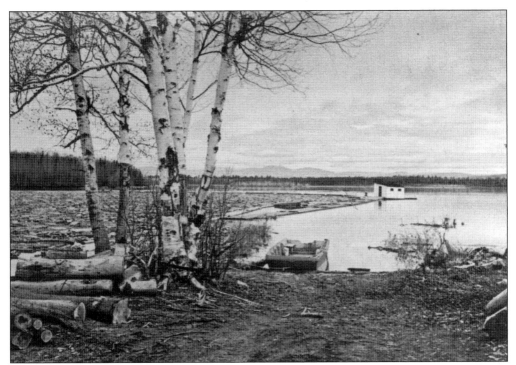

A raft or boom of 4-foot-long pulpwood is tied up at the boom house on the upper end of the lake, near what was Arnold Falls in the old original river channel. (Courtesy of KRW.)

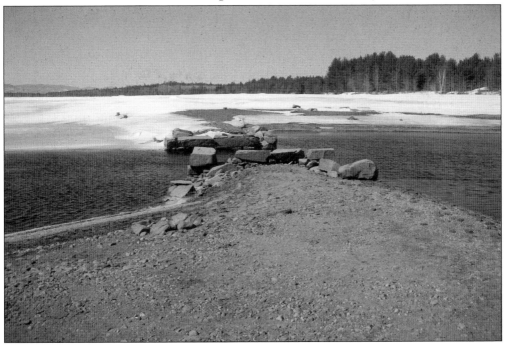

The Mill Stream Bridge abutments are shown here in March 2009. This is all that remains of the bridge on Main Street that spanned Mill Stream and the outlet to the old Flagstaff Pond. (Courtesy of DEW.)

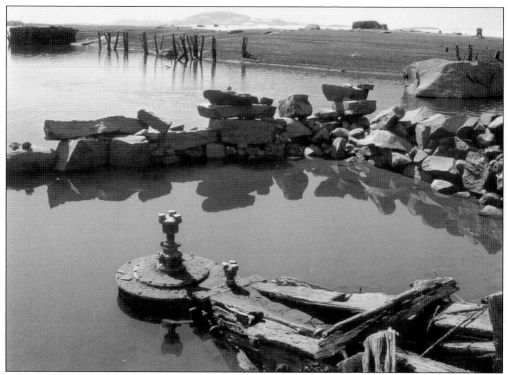

An early-1990s photograph shows the remains of the H. G. Bryant Mill turbine and penstock. (Courtesy of DEW.)

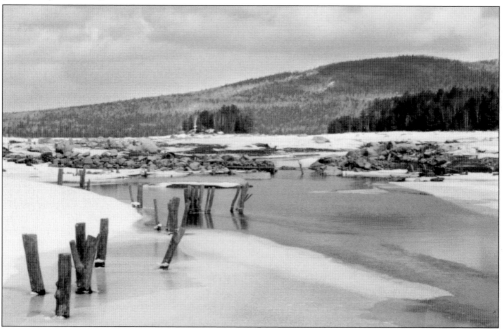

A 1992 early springtime view up Mill Stream shows the dam and where the H. G. Bryant Mill once stood. The stumps were cut higher than normal because the trees were cut a year after the lake was created and cut at ice level when there was more water in the lake. (Courtesy of KRW.)

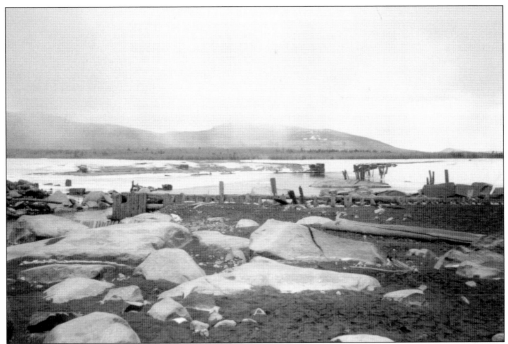

Another 1992 early springtime view looks down Mill Stream at the dam and where the Mill Stream Bridge once stood. (Courtesy of KRW.)

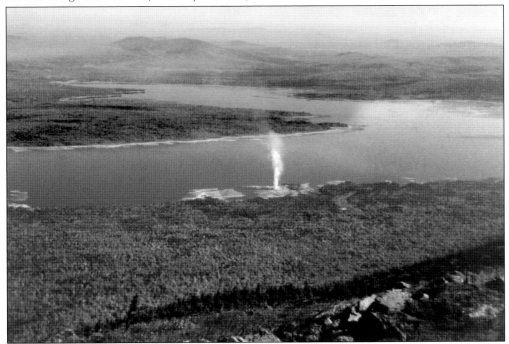

The round barn on the Charles T. Rand farm was not flooded out, but it accidentally burned in the process of an attempt to salvage it in September 1952. This photograph was taken from the Maine Forest Service fire tower on Mount Bigelow by watchman Franklin Sargent. It shows the smoke plume from the final chapter of this unique structure. (Courtesy of Franklin Sargent.)

www.arcadiapublishing.com

Discover books about the town where you grew up, the cities where your friends and families live, the town where your parents met, or even that retirement spot you've been dreaming about. Our Web site provides history lovers with exclusive deals, advanced notification about new titles, e-mail alerts of author events, and much more.

MADE IN THE USA

Arcadia Publishing, the leading local history publisher in the United States, is committed to making history accessible and meaningful through publishing books that celebrate and preserve the heritage of America's people and places. Consistent with our mission to preserve history on a local level, this book was printed in South Carolina on American-made paper and manufactured entirely in the United States.

This book carries the accredited Forest Stewardship Council (FSC) label and is printed on 100 percent FSC-certified paper. Products carrying the FSC label are independently certified to assure consumers that they come from forests that are managed to meet the social, economic, and ecological needs of present and future generations.

FSC
Mixed Sources
Product group from well-managed forests and other controlled sources

Cert no. SW-COC-001530
www.fsc.org
© 1996 Forest Stewardship Council

Find Your Place in History.